PAVEMENT CHALK ARTIST

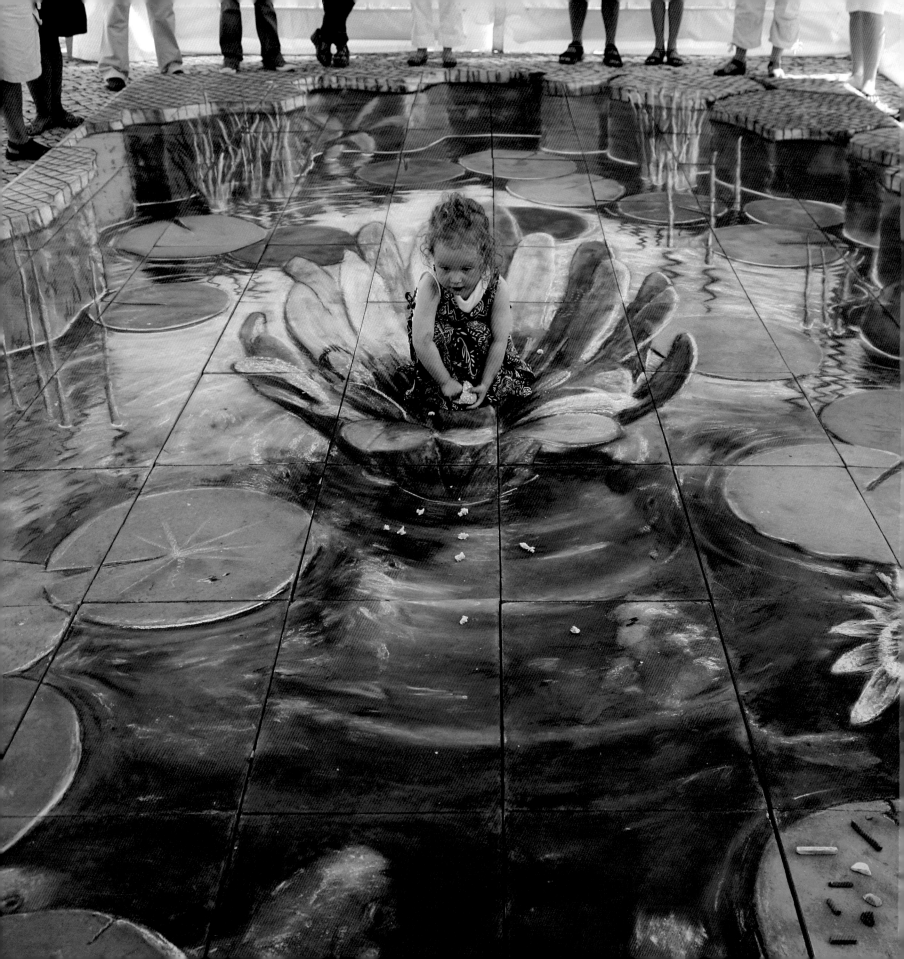

PAVEMENT
CHALK ARTIST
The Three-Dimensional Drawings of Julian Beever

Julian Beever

FIREFLY BOOKS

A FIREFLY BOOK

Published by Firefly Books Ltd. 2010
Copyright © 2010 Firefly Books Ltd.

First printing

Publisher Cataloging-in-Publication Data (U.S.)

Beever, Julian, 1959-
 Pavement chalk artist : the three-dimensional drawings of
Julian Beever / Julian Beever.
[112] p. : col. photos.; cm.
Summary: Includes a selection of Beever's most intriguing
anamorphic drawings, each accompanied by a description of the
techniques he used and the challenges he overcame.
ISBN-13: 978-1-55407-661-1
ISBN-10: 1-55407-661-7
1. Beever, Julian, 1959-. 2. Anamorphic art 3. Artists – Great
Britain – Biography. I. Title.
709.7309045 B dc22 N7433.6B448 2010

Library and Archives Canada Cataloguing in Publication

Beever, Julian
 Pavement chalk artist : the three-dimensional drawings of
Julian Beever / Julian Beever.
ISBN-13: 978-1-55407-661-1
ISBN-10: 1-55407-661-7
 1. Beever, Julian. 2. Anamorphic art. 3. Anamorphosis
(Visual perception).
I. Title.
NC242.B44A4 2010 741.092 C2010-902716-7

Published in the United States by
Firefly Books (U.S.) Inc.
P.O. Box 1338, Ellicott Station
Buffalo, New York 14205

Published in Canada by
Firefly Books Ltd.
66 Leek Crescent
Richmond Hill, Ontario L4B 1H1

Printed in China

The publisher gratefully acknowledges the financial support for
our publishing program by the Government of Canada through
the Canada Book Fund as administered by the Department of
Canadian Heritage.

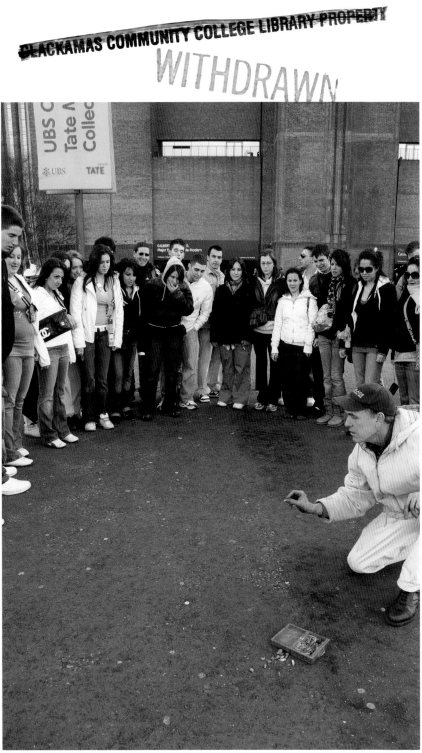

3D DRAWING OF THE INVISIBLE MAN | LONDON, ENGLAND

This drawing was done outside Britain's principal modern art gallery, Tate Britain, in London.

CONTENTS

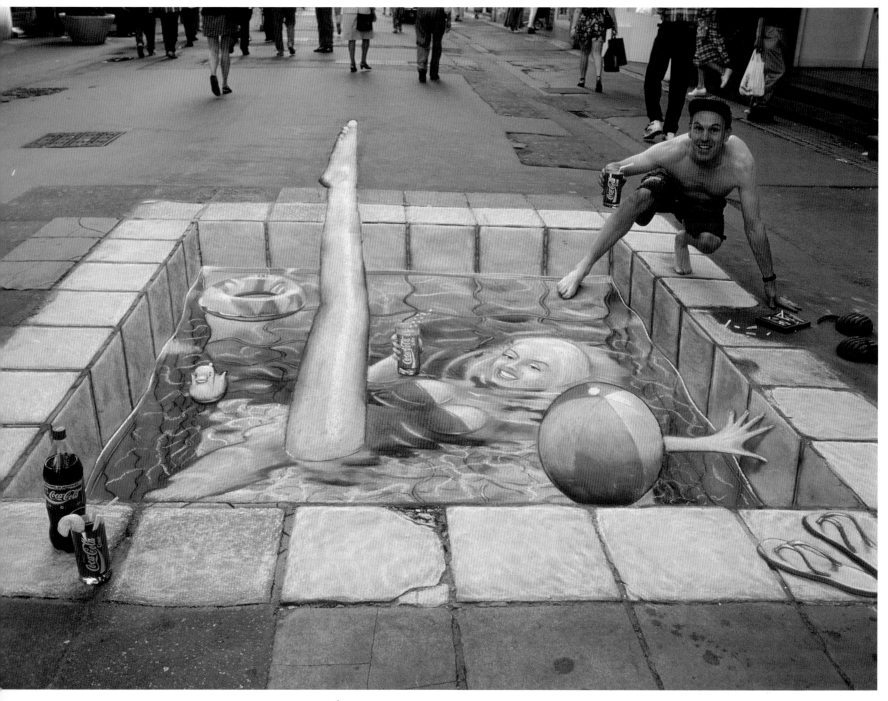

SWIMMING POOL IN THE HIGH STREET | BRUSSELS, BELGIUM

INTRODUCTION

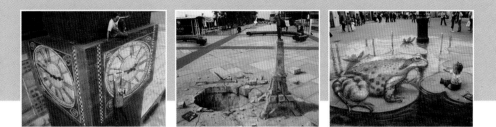

SWIMMING POOL IN THE HIGH STREET

When I am working on a drawing I am often asked by journalists and passers-by how I got started on 3D pavement art. I usually take as my starting point the drawing entitled *Swimming Pool in the High Street*, as this was my first anamorphic pavement drawing. The next question is often, "What does anamorphic mean?" An anamorphosis is something that is drawn or exists in a distortion, and can only be resolved and seen in its rightful shape when viewed from a particular angle or through some counter-distorting mechanism such as a lens. All the anamorphic drawings in this book must be seen from one viewpoint and work most convincingly when seen through a camera, that is, through a lens. They also work as 3D illusions when we look at photographs of them, but then these photos are actually records also seen through a camera lens.

But *Swimming Pool in the High Street* was not the starting point of my career but rather a turning point, and even then only when seen in hindsight.

I grew up in a small town called Melton Mowbray, almost exactly in the center of England. I was brought up to take school seriously, and was lucky to have parents who took a loving interest in my growth and school career. I was encouraged to draw at home, and my memories of this go right back to my earliest years of using pencils to fill in coloring books, completing join-up-the-dots pictures and dabbling with watercolor paints.

I never really liked school. I was much happier structuring my own time. When not drawing I would be playing with friends, usually in our orchard, going fishing, exploring nature or collecting butterflies. These themes still feature in my drawings today. I did enjoy one thing at school, however: the art lesson. On the first day I went to infant school, aged five, we were asked to draw a picture. I was surprised to see that none of the other kids in my class could draw at all. It was at that point that I realized I was good at art.

In England, at sixteen, students had to either leave school or do "A" levels. I chose Art, Design and Psychology. Art I excelled in. Design was a tedium and Psychology, which I took at the last minute as a substitute for English, was an unexpected and useful surprise. Of later significance, I learned about depth perception and the mechanisms the eye and brain use to work out the distance of objects from the viewer.

After that followed a gap year of languishing

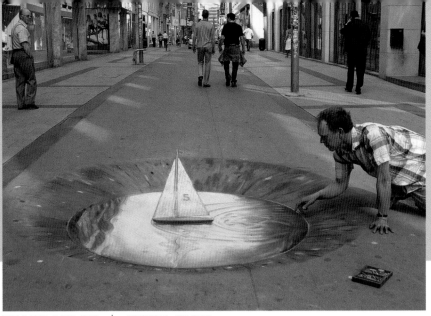

In order to do this drawing I went to a pond when the light was reflecting beautifully on the surface and had myself videotaped pushing a piece of wood out from the bank. Stills taken from that video showed me exactly how to draw the ripple effect that I needed.

PUSH THE BOAT OUT | BRUSSELS, BELGIUM

at home, then working as a laborer and then as a carpet-layer's assistant.

The following year I did a Foundation Art course at Leicester Polytechnic and then went on to do a three-year BA in Fine Art at Leeds Polytechnic. The Foundation year was a great success, and I experimented in a variety of modern art forms. Again, I enjoyed being "top of the class" in art.

Leeds Polytechnic, where I found myself a small fish in a much bigger pond, was a different story. Few of the lecturers or students were friendly, and the atmosphere, characteristic of the self-important "avant-garde," was neither indulgent nor sympathetic. It was a cynical period when pacifism and liberalism were giving way to punk, mockery and irreverence. Now living away from home, I soon lost sight of why I was there and became disoriented in my artistic direction. I was put on probation, and only to avoid being kicked out of the course did I make a decision to do some work.

In a world of avant-garde, where it seemed anything was art if you could argue the case cleverly or aggressively enough, my way back to solid ground and to finding my identity was to return to tradition. I chose the study of water surfaces, a theme that had interested me, and which gave

me a chance to work outdoors at riverbanks and ponds, and escape the college environment. Afterward I worked up my sketches into oil paintings. The subject of water is one of the most difficult an artist can take on and I struggle with it to this day.

One lecturer introduced me to pastel crayons to use on my field trips in order to work fast on a moving subject. I have often said that in my three years at college I didn't learn anything that I could not have learned on my own. My introduction to pastels was an exception and one of two key events that happened at college.

In the summer before my last term I went to the 1983 Stonehenge solstice free festival. In this unlikely setting I saw a performer named Tim Bat do an extraordinary juggling display. I watched his act through three times and decided on the spot that I wanted to be a juggler. I began practicing right away. When I returned to college for my final year the second key event happened. By happy coincidence I met two other students who were jugglers, and we exchanged tricks. They also did an escapology act and they told me how they performed in the streets of York, gathering crowds and collecting money in a hat from the passers-by

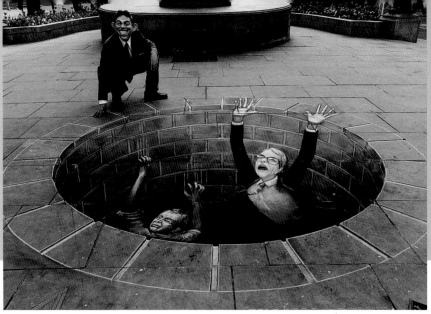

POLITICIANS MEETING THEIR END | LONDON, ENGLAND

who stopped to watch. Before that point, such an activity would never have crossed my mind.

Until then I had always shied away from public performance. I once spoke to a performer in Paris who described himself as an extroverted introvert. I felt I had to become something like that. Having learned to do basic juggling, I set off for the tourist city of York to try out my skills.

Volumes could be written on how to do street entertainment; it isn't easy to get started. Simply standing in one spot juggling is of no interest to anyone, no matter how talented you are. The secret lies in the ability to make a random collection of individuals into a cohesive audience, to create an expectation, to amuse them and keep them wanting more as you work through a structured and reliable routine, finishing in a climax — in my case, juggling fire torches. But perhaps more important still is an internal change — to believe in yourself as a street performer and lose your fear.

Once you have this confidence, not only is performing a way to make instant cash, but it is strangely liberating to your consciousness. You get a feeling almost of omnipotence. A performer has a license to behave more extremely than anyone else and people will applaud. Years of self-repression

undo themselves! You then start to enjoy a tremendous sense of freedom in the street.

And yet it didn't come naturally. There was a limit to my physical ability at juggling and my self-confidence tended to crash when other entertainers who had been doing it for years and were much better than me arrived on the same pitch.

I found a way to graduate from the juggling scene by deciding to build and perform a Punch and Judy puppet theater. This allowed me more scope for artistry in making the puppets and, while it still demanded a certain extroversion, it allowed me to hide myself in the booth!

In creating the puppet theater I purposefully avoided looking at other Punch and Judy shows in order to keep mine original. The show was a great success and I felt much prouder of this than of my earlier act. The streets had become my home.

Once I felt the puppet show could not progress and my routines were as good as I could get them, the work became all too repetitive. In York I often saw pavement artists working outside York Minster. They had to work long and hard compared to the street performers I mixed with, but at least they didn't have to put themselves on show. Their spectacle was their drawing. I was also struck by

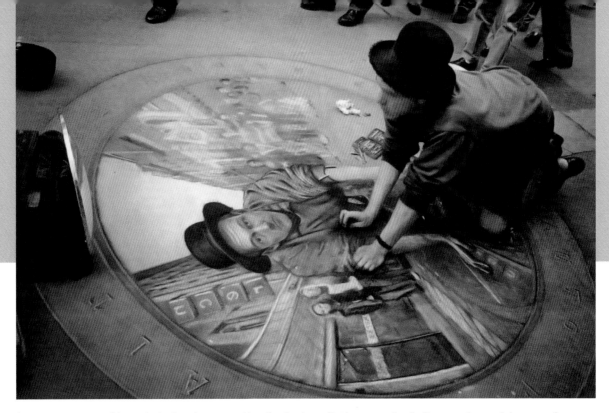

In my pre-anamorphic period when I was working for the benefit of passers-by, I often used roundels as my frames. I cannot remember where I found the convex mirror, but this was the key to the picture. I set this up against a box so that it gave a good view of me in front of it crouched in the act of drawing. Behind, and compressed by the convex glass, the street itself was visible, including those who stopped to watch.

the fact that they could move from place to place with only a box of chalks – unlike me with all my cumbersome equipment. And I felt that I could draw just as well as they could.

Until then I had never been outside the UK and I wanted to see more of the world. It seemed that I had discovered a way to travel and finance it en route. And so I came to pavement art. My first street drawing, done with a friend, was a portrait of William Shakespeare outside his birthplace in Stratford-upon-Avon. Soon afterward I made a trip to America and then to Australia, paying for the tours by doing pavement art with a hat beside the drawings. I made no fortunes but I probably broke even, offsetting the costs with the takings.

After this I visited some European countries, living and touring in a camper van. Over this period I learned by trial and error what to draw and what

not to draw in order to interest the public and entice people to throw a coin in a hat. I make no apology for being a populist. If as a pavement artist, you don't draw what the public want to see and you are dependent on them for tips, you will become discouraged and give up. Beautifully drawn portraits of well-loved or national heroes and icons are popular. These I did and refined my skills with pastels as far as I could. Good quality pastels used on a good cement or stone surface can give an effect second to none – better than on paper.

As I homed in on what I discovered to be the best pitches in different cities around Europe, I began to find that I could make a living at this. Weather and officialdom were the main obstacles, but there were many other factors to consider as well. The quality of the surface is vital. The number of passers-by is critical. Being in a space that is

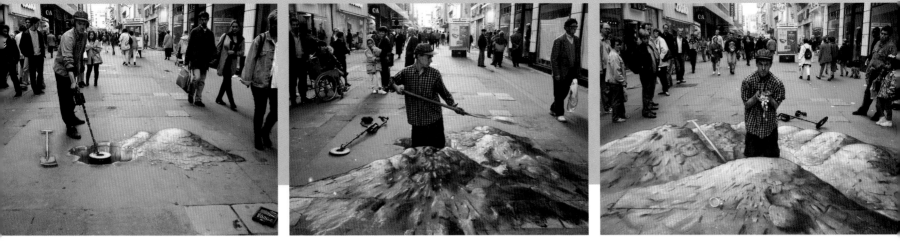

It is surprisingly easy to draw holes in the ground but surprisingly difficult to draw heaps of earth. Although piles of earth are messy and seemingly random, their surface is actually composed of a great deal of detail. They have to be drawn so that the texture is different in the surface of the pile facing and the surface turned away. I liked the clod of earth in the third picture, which was drawn to appear to be moving in mid-air leaving the spade. The effect in the last photo in the series was managed because, of course, I knelt down on the ground pretending to be standing.

neither too big nor too small makes a great difference, and one must avoid causing an obstruction. Another factor is whether there are already other artists working in that street. Being the only one is a great deal better than being "another." And so I learned my new trade.

It is exciting to be an itinerant, discovering new places and people, but at the same time it is exhausting. After a while the one thing you want is a reliable spot where you know you can do your stuff without being moved along and get some payment for your efforts. I found a spot in Brussels that fulfilled all the requirements and for some time I would regularly do a weekly drawing on a different popular theme. The *Mannekin Pis*, the Belgian Royal family, the *Mona Lisa* were all successes.

The particular pedestrian street where I worked happened to have some unusual features in its surface. There had once been mini-gardens along this street, which had been removed and covered over. This left an unusual homogenous asphalt surface that was interrupted at intervals by rectangles of embedded tiles where the gardens had once been. I took to using these rectangles as ready-made frames for my portraits. All these portraits were conventional two-dimensional drawings seen perfectly only from above. (The audience never actually sees them perfectly from above, but our eyes and brains make allowances for this perspective, and viewing from the side doesn't cause a problem.)

I had been doing this regularly for some time when I had the idea of using one of these rectangles as the outside edge of an imagined swimming pool. The tiles were already there, and I only had to color them in. Then I needed to draw the inside of the pool – the water, the reflections, the broken light from below the surface, a bather, a beach ball and some toys. Then I realized that I could only make the water level appear lower than that of the tiles, by looking at it from one side only.

I did not know the term at the time, but this was my first anamorphic drawing. This is how I arrived at the turning point in my career.

For an anamorphic drawing, I begin by sketching out the picture in black and white as it should be seen from the viewpoint – not from above – in a small sketchbook, using soft 5B pencils. At this stage I correct a lot with an eraser. The sketch is only in black and white; the colors I will eventually work out in my mind without having to prepare tests.

The drawing on the ground will of course have to be stretched and distorted so that it looks correct from one viewpoint. I do not plan or prepare the distortion.

Once the site in the street is selected, I set up a camera on a tripod, focusing it down toward the sidewalk. The view through the lens becomes the chosen view from here on. The job then is to translate the image in my sketchbook onto the sidewalk so that it can be seen through the camera as I wish.

With any drawing I start by considering the broad features of the composition. For example, if I am drawing a cube set in a hole in the ground, my first task is to draw the outline of the hole. I do this by laying a rope out on the sidewalk and checking its position when viewed through the camera. When it looks the right size and shape, I mark the outline in white chalk.

A 3D artist must work within certain rules.

All vertical lines should eventually converge at a vanishing point below the camera. Bearing this in mind, I then attempt to establish the vertical sides of the hole (if indeed I wanted them vertical). That done, I have a space below ground in which to visualize and then position the cube.

As the cube has a flat horizontal top, there is no need to stretch or distort it because it is seen on a horizontal floor. All four sides of the top only need to be drawn as a square. Nevertheless, these sides will appear to be converging eventually at a vanishing point in the distance, on the horizon. This will be the effect of natural perspective as seen on everything else in the view, which is getting further away from us both in and outside the drawing.

As with the vertical sides of the hole, the vertical sides of the cube too will converge at the vanishing point below the camera. If there are other verticals in our view, for example, some lampposts in the background, we will see that these too will converge at the vanishing point. It's nothing esoteric. I am only observing the rules of perspective as they apply to all things in the view!

The height of the cube and the height of the sides of the hole are judged by checking through the camera. In other words the lines running to and from the vanishing point below the camera

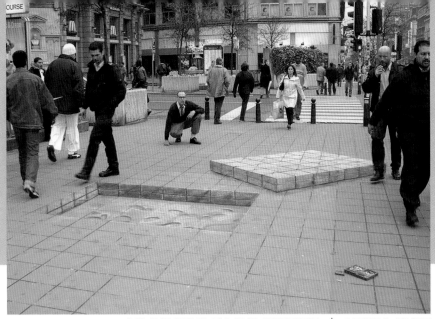

PRE-MODERNIST AND POST-MODERNIST | BRUSSELS, BELGIUM

will extend backward on the ground away from the camera, to a point where they appear correct. If this arbitrariness seems surprising, remember that nearly all drawing is done simply by judging these kinds of distances and proportions intuitively so that they look correct.

Working in this way, I soon have the outline of the forms. Of course there are many forms that are not built from horizontal and vertical planes. But to a certain extent these principles still apply. A line or plane must after all be situated somewhere on a continuum between the vertical and horizontal. If in doubt I experiment with a rope and check it.

Up to this point I use white chalk because it is the easiest to wash off if I make a mistake. And that's quite often! Once I am happy with the outline, I wash off the white chalk and replace it with a more definite black outline.

This is the moment to settle on the light source, to decide which direction the light will come from? Once this is determined, the shading and shadows cast by the cube can be filled in accordingly and consistently. It is now that the picture starts to look 3D. Black must be used for the darkest shadow and white only for the brightest highlight. These are the limits of our tonal range. All other tones can be filled in somewhere between. Colors are then a matter of choice and taste.

For a sidewalk drawing I use dry pastel chalks. For large areas I use powdered pigment that I rub in using blocks of expanded polystyrene foam. This saves my fingers.

At no point do I really consider how the drawing looks in its distorted form from above, as this is irrelevant. I only ever consider it from the viewpoint of the camera.

I use no mathematical formulas or computer programs. I never really know whether a drawing will come out as well as I hope. For me perhaps one in four is a success and one in four a failure; the others fall somewhere in between. Mostly it is a matter of luck.

The Three-Dimensional Drawings of Julian Beever

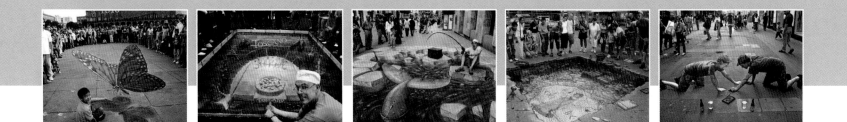

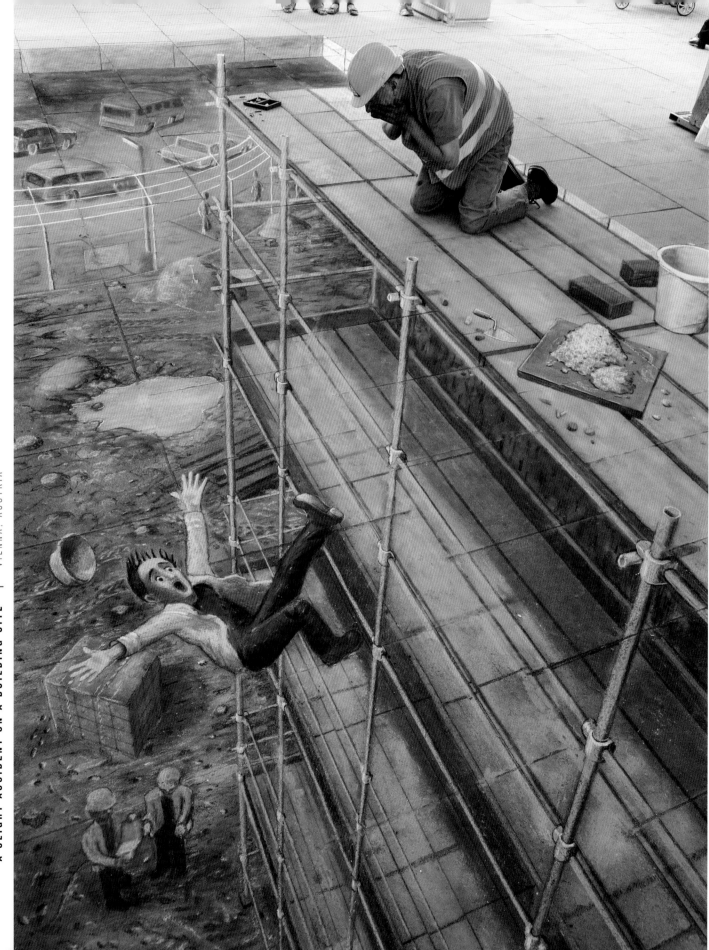

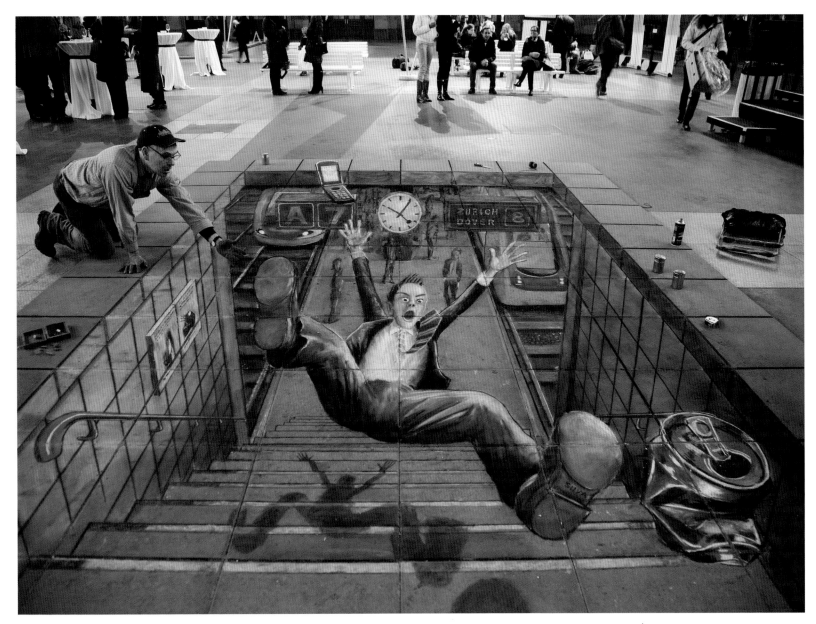

A SLIGHT ACCIDENT IN A RAILWAY STATION | ZURICH, SWITZERLAND

A SLIGHT ACCIDENT ON A BUILDING SITE

When we think about perspective, most of us remember art lessons at school where we drew railway lines arriving at a vanishing point on the horizon. That explains horizontal lines. What few people realize is that all vertical lines (parallel ones at any rate) also have a vanishing point. Two, in fact. When we are looking up at them the vanishing point is above our head. When we are looking down at them, as in this picture, the vanishing point is below our feet. Or more precisely, below the camera. So here I used a string to "pounce" the vertical lines to this common point. These are the vertical yellow tubes of the scaffolding. As for the horizontal lines — the wooden planks — they are actually drawn parallel. The real effect of perspective, based on the increasing distance of these lines from our viewpoint, is that they would, if extended, eventually converge by themselves.

I deliberately used a minimal palette in this picture, sticking mostly with yellow and brown. I wanted to give it a classic, retro feeling.

A SLIGHT ACCIDENT IN A RAILWAY STATION

Accidents are terrible things that we all try to avoid but they do make good subjects for 3D drawings when drama, action and depth combine. This drawing attempts to capture that awful moment when an accident is just happening and time seems to slow down in to an age-long millisecond. The action is frozen.

I tried to focus all the viewer's attention onto the man and his look of terror by placing him centrally in the picture and his face at the point where the perspective lines of the steps would converge. I also wanted to home in on him by drawing him more crisply than the vaguer forms of the scene in the background. Notice the many classic "single point" perspective lines that we learn about at school, taking our eye in to the distance.

My simplest answer when asked how I make things look 3D is to say that I draw the distant things bigger and the closer things smaller, thereby confusing the brain's understanding of distance. But here I did the opposite — at least on the tin can, which is, of course, the cause of the accident. Even though this is close to us I drew it extra large to give a really exaggerated feeling of it flying close toward us. Shadows on the stairs help give the feeling of flight.

I posed myself on the floor both at home and in the station to help work out a dramatic pose using my camera's self-timer. You mustn't worry too much what others think in these situations.

UNDERGOUND BANK AT BANK UNDERGROUND

This was one of the first drawings in which I tried to cover over the lines between the paving stones. It was especially necessary here because I tried to make the bank vault look as if it were sunk into the paving stones themselves. Cement is no good for this because it leaves an unsightly permanent filling between the stones, and also because it dries too slowly. My solution has been to use plaster, which unfortunately has several drawbacks. First, chalk does not adhere well to plaster so I mix in some sand to give it texture. Second, it is usually a brilliant white color and stands out badly even when chalked over. I try to compensate for this by mixing in pigment to match the surrounding pavement.

 A further difficulty in getting a perfect match is that plaster with pigment dries a great deal lighter than its color when wet, and I have to allow for this when adding the pigment. One good method is to wet the paving stone you are trying to match. The wet patch will look a lot darker, but if you mix up your plaster to this color, the paving stone and the plaster will usually dry to look more or less the same. Usually! This was an early drawing and my technique was far from perfected.

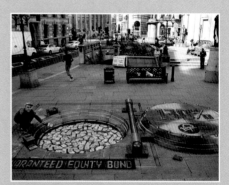

BATMAN AND ROBIN TO THE RESCUE

For most of my drawings I do quite a bit of planning and sketching. But funnily, I only came up with this idea late at night in my hotel room the day before I was to begin. It followed soon after the Spiderman drawing and I wanted to do something similar but better in the same spot. I was looking at the photo of the Spiderman drawing when the idea struck me of including the wall at the side in the artwork. One limitation of pavement art is that we always must look down on it. But if we include objects like the wall, the range of the scene is extended much higher. We can integrate the above "real world" far more effectively with the world below. The whole street scene can become our canvas.

 Most of my time on this drawing was spent meticulously measuring and plotting out the geometry of the windows and brickwork of the main building facing us. Then, the positioning and drawing of our two heroes, which needed to be drawn quite stretched at this distance, demanded quite some time and effort to get right. It was important to make the sill that I am squatting on appear real, by shading it with a strong contrast between light and dark. Once these things were done, the background scene more or less drew itself.

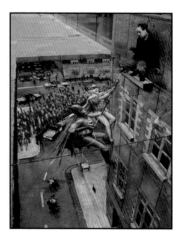

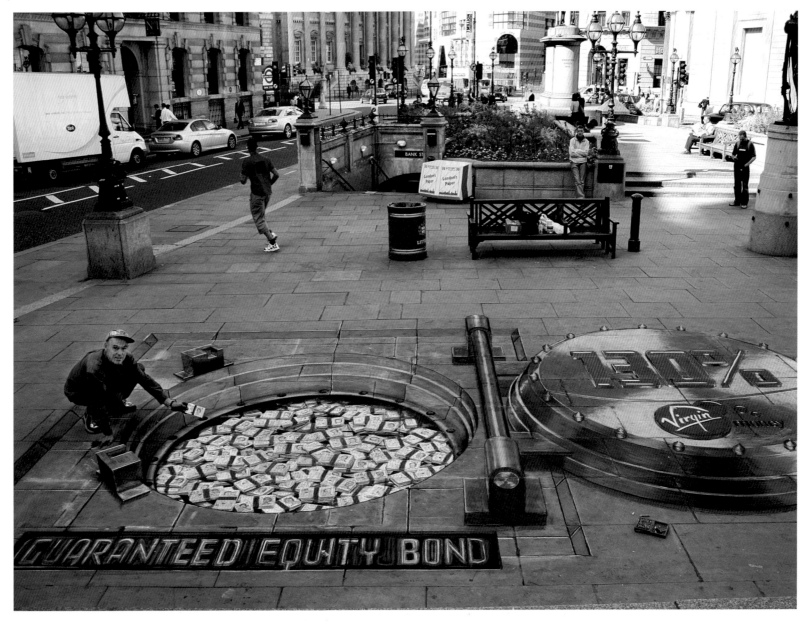

UNDERGROUND BANK AT BANK UNDERGROUND | LONDON, ENGLAND

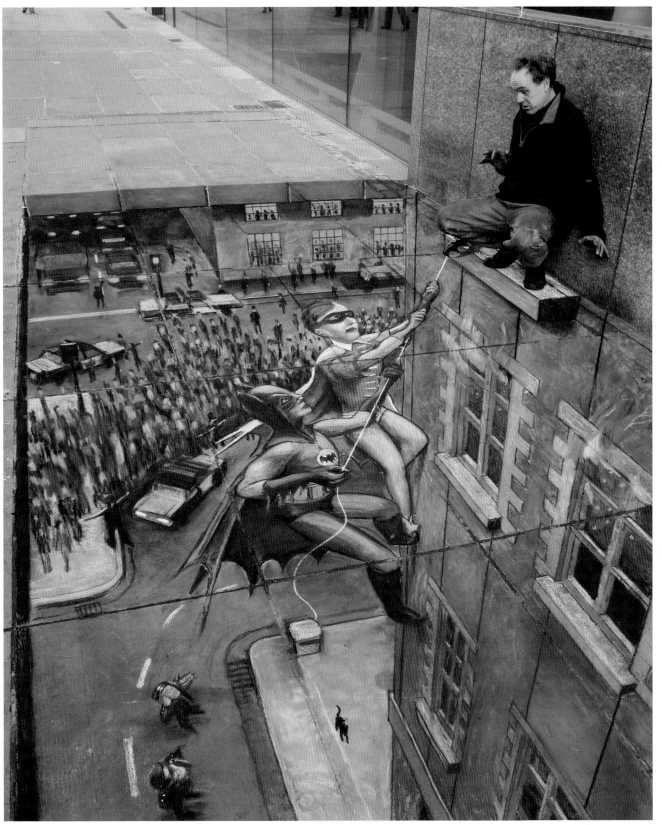

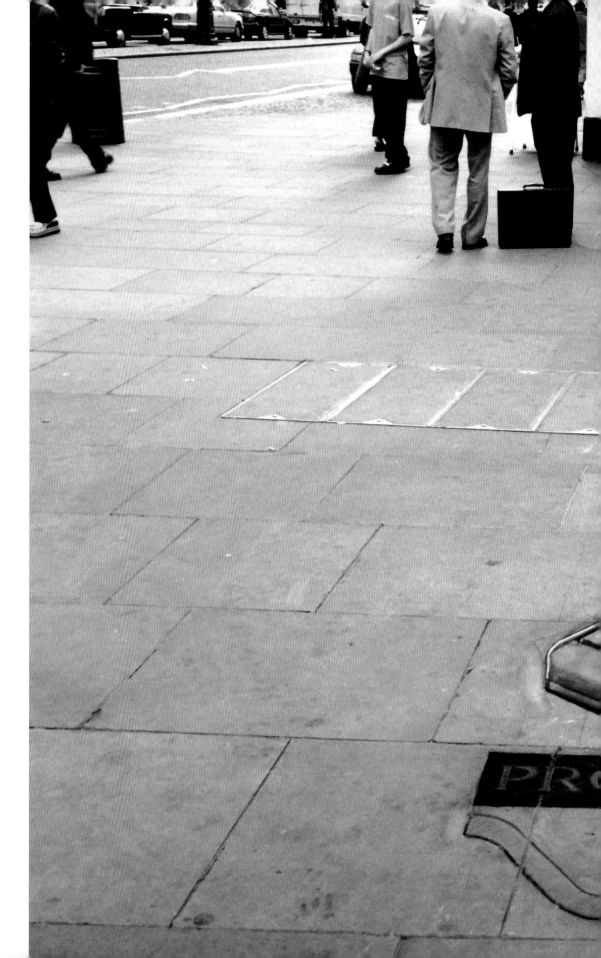

COMPUTER IN THE STRAND

LONDON, ENGLAND

This was another early drawing from the time when most of my income came in hats. It was still early days for laptop computers and I had never owned one.

Seeing a lovely piece of pavement on a corner in the Strand in London, I went into the adjacent shop and showed the salesperson my photo album of pavement drawings. I suggested I could do one outside the shop advertising their computers. They happened to be planning a promotion, and this idea fitted in perfectly.

When drawing objects on the sidewalk it is often a good idea to draw something flat "underneath" them so that the object really does look to be on top of the pavement. Otherwise it can seem to be floating in space. In this case I used the logo.

Even though the drawing was directly outside the shop, the local authority hadn't granted permission, and an officious representative of the law was soon on the scene demanding that the picture be stopped. My patron urged me to press on, and a running argument developed. A compromise was reached whereby the drawing had to be removed as soon as it was completed.

So that was how I got my first laptop.

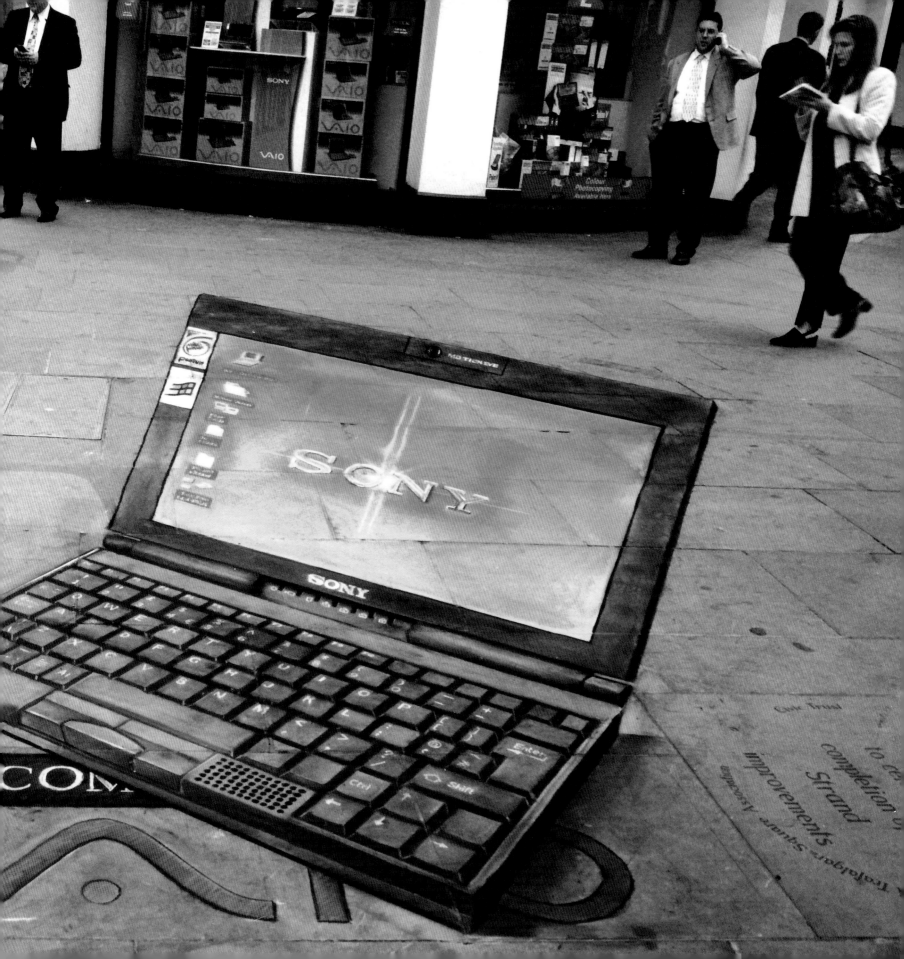

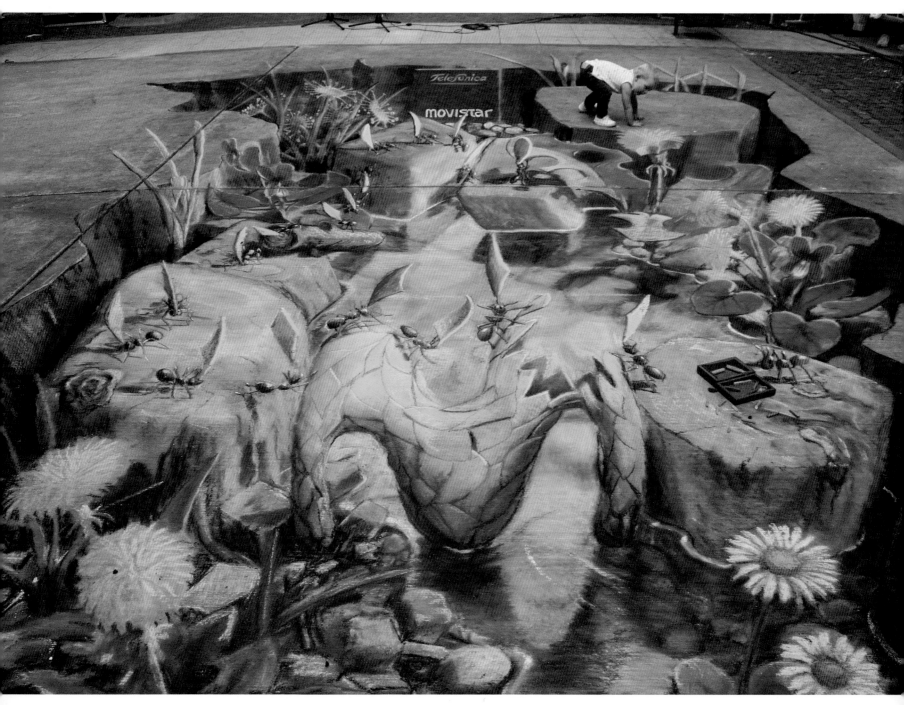

LEAF CUTTER ANTS BUILD A BRIDGE | BUENOS AIRES, ARGENTINA

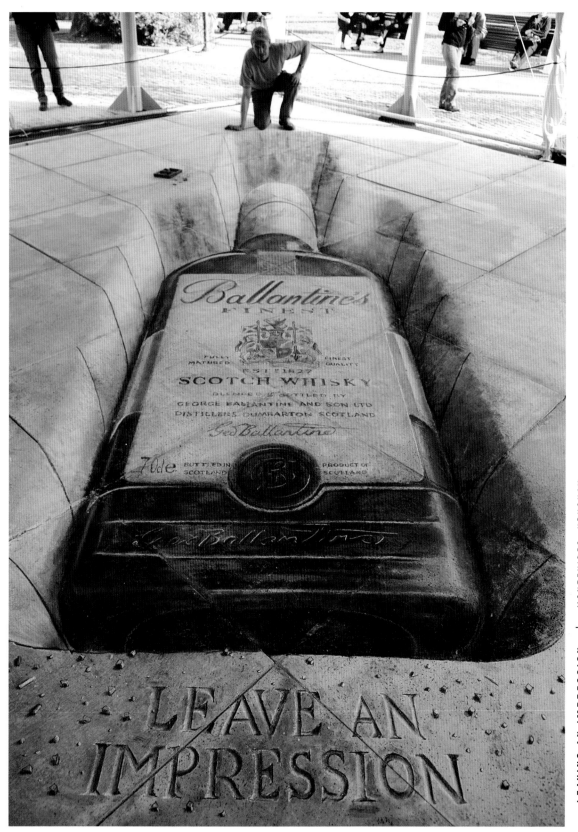

LEAF CUTTER ANTS BUILD A BRIDGE

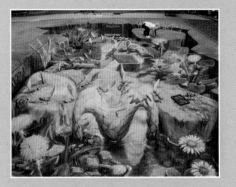

This was my first drawing of a macro landscape — a view of the ground very close-up. Before starting I took a series of photographs of my own gravel path with water poured on it to get a sense of how water looks at this close-up range. It is amazing what a complex world exists beneath our feet that we rarely take the trouble to look at.

In Buenos Aires at the time there was ironically a pall of smoke shrouding the entire city, caused by agricultural fires in the surrounding countryside. It wasn't pleasant to breathe but it did give a nice soft diffuse light without harsh shadow, which was great to work in and made for a good final photo.

One of the things that most attracts me to drawing water is the balance between the view below the water and the reflection coming off the surface. This and the seemingly random nature of the pebbles and debris found beneath our feet were to me the essence of this picture.

LEAVING AN IMPRESSION

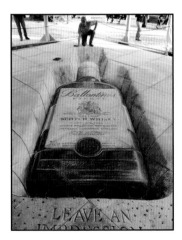

I am often asked to do drawings that create a dizzying sense of height and great depth. While these are good challenges, I think that a shallow depth can often be more impressive. Perhaps because it is not overly ambitious, a drawing of a bottle pushed into a shallow depression can be more deceptively real than an image attempting to simulate a drop of hundreds of feet. I went on to do several variations of this drawing for Ballantine's, but this one was the first. I presented the bottle much as I saw it laid down in front of me. Later variations differed in that I tried to show the bottle as if it were glowing.

SPIDERMAN OVER LONDON

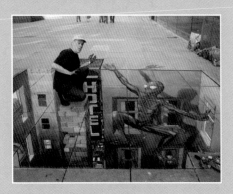

In drawing a figure on the sidewalk you somehow have to create a space in which your figure can move. One way is simply to draw it as if it were closer to you than it is, and standing on or above the surface. The other way is somehow to create some space below ground, as I did here.

The verticals of my space are all sides of buildings drawn in plain but bright comic-strip-style colors. The idea is that our hero is actually coming to rescue a real person posed on the crumbling chimney-stack. His shadow is cast sideways onto the wall behind. In a way a figure like this one is drawn almost as if he is a projection in reverse, not coming from but going into the camera. What I find most difficult is drawing a projection from the projection, that is, his shadow. I had to go back and forth at every point to get this right.

The sandbags seen behind were used to hold down a plastic sheet for night-time protection. I arrived on the second morning to find that during the night someone had removed my cover, emptied out one of the sandbags and carefully sculpted a chapati-shaped plateau on top of the drawing. It is amazing what trouble some people will go to in order to cause trouble for someone else.

CRICKET IN ST. LUCIA

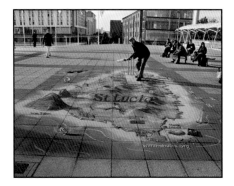

At the time, this was probably the largest pavement drawing I had done. My girl-friend helped me color in the sea.

The project was meant to sell St. Lucia as a tourist destination and in particular the fact that it was hosting cricket's World Cup. The concept came to me because I remembered as a boy doing jigsaws of Africa and South America that were in the shape of these continents, with lovely illustrations of scenes and certain areas highlighted.

It was a bitterly cold period in winter when it was drawn, and the wind blew a lot of the chalk off the surface, so I was less able to generate the strong colors and shade needed to give this the fullest 3D relief.

But I was pleased with the cricket stumps, which on the ground receded a very long way. They were longer than all the rest of the drawing. To ensure that they appeared vertical and equally spaced, I took careful measurements, and "pounced" the lines using long lengths of string anchored at a common point below the camera.

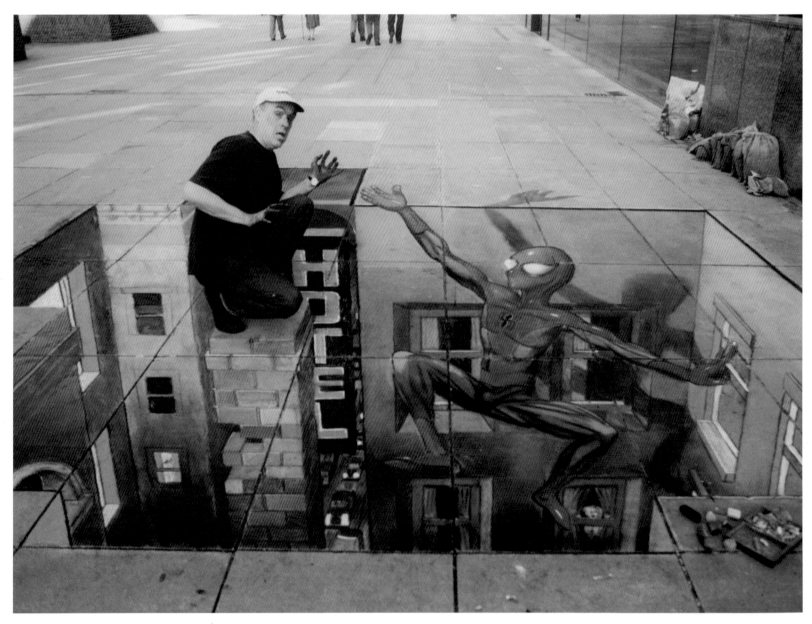

SPIDERMAN OVER LONDON | LONDON, ENGLAND

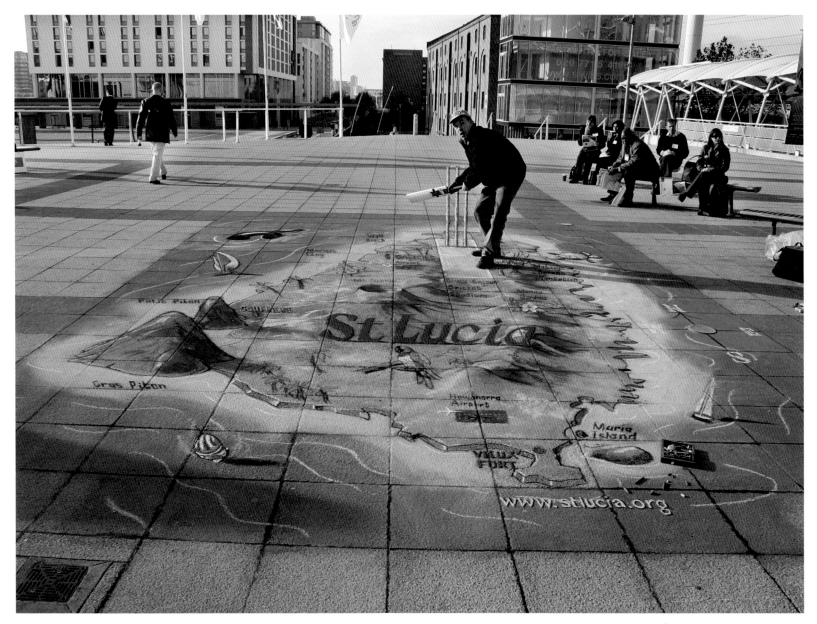

CRICKET IN ST. LUCIA | LONDON, ENGLAND

This drawing in Tokyo was done to promote the film of the same name. It was exciting to visit the city for the first time but there were several factors working against the drawing. It was extremely hot and I was working under a plastic tent. The surface was too shiny to properly hold the chalk, so none of the colors, particularly the black, attained the solidity they needed. The problem was compounded by the strong grid of paving slab outlines reminding the eye that this really was a flat surface. The slabs were so small and the lines so extensive that there was no time to fill them.

On top of this, the client and his entourage, all wearing suits, would regularly come to follow my progress. They had ongoing heated discussions among themselves in Japanese as if something were very wrong. When I enquired if there was a problem they became very polite and assured me that everything was fine. But they would then ask if I could make changes to the plans, which had been agreed upon long in advance. When taking on commissions I can usually be flexible enough to find a solution that satisfies the client's needs while retaining my own artistic integrity.

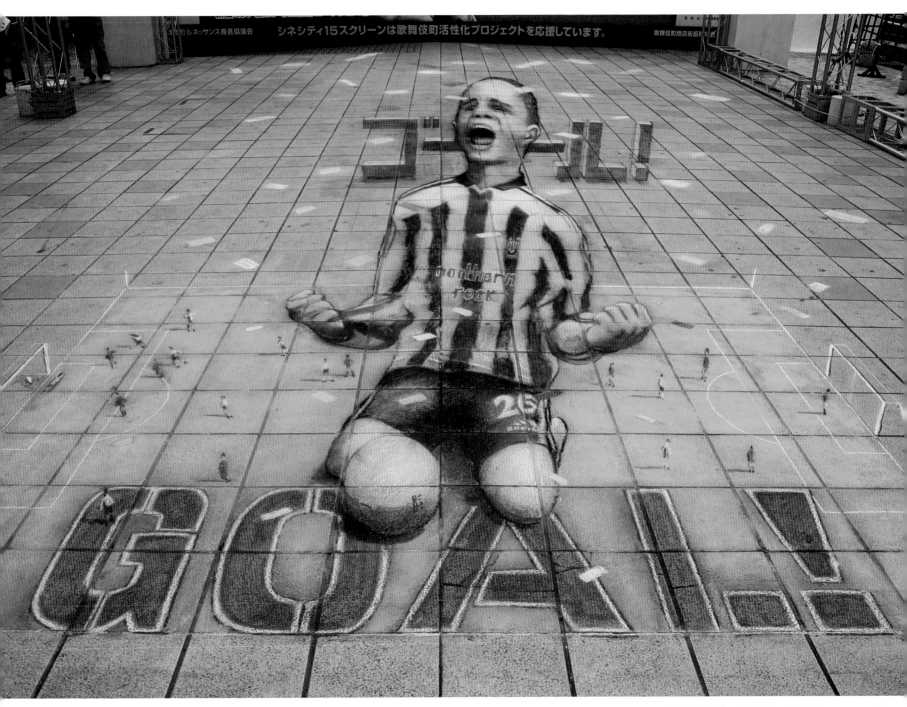

GOAL! | TOKYO, JAPAN

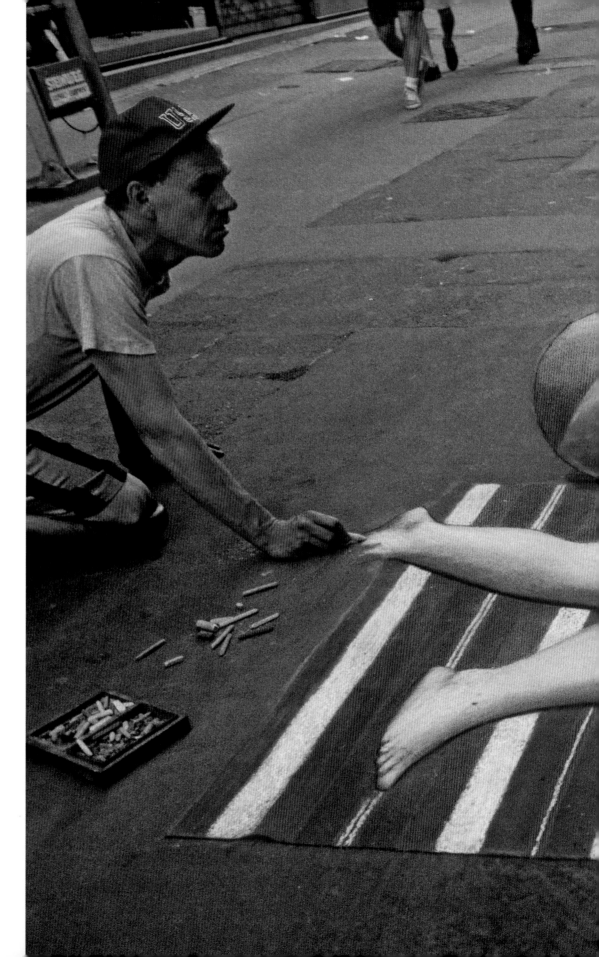

GIRL ON A BEACH MAT

BRUSSELS, BELGIUM

Each drawing that you see in this book is actually not a drawing but a photograph of a drawing. The way it is photographed is very important. In particular, whether it is a wide- or narrow-angled lens makes a lot of difference to the perspective. If I use a wide-angled lens to photograph a drawing, I have to draw it so that it will look correct through a wide-angled lens (as opposed to a narrow-angled or telephoto lens).

The advantages of a wide-angled lens are twofold. Because the perspective is exaggerated (for example, the paving stone lines going into the distance converge more abruptly), when something that is drawn as if solid, defying the natural perspective, the resulting illusion is all the more compelling. The second advantage is that a wide angle allows the camera and the viewer to be closer to the drawing and more intimate with the subject. Naturally, one would need to stand back further for a narrower-angled lens.

These then are some advantages. But as any portrait photographer knows, a wide-angled lens also distorts the features. Noses can look grotesquely too big. And equally, a human figure lying on a mat can look distorted as if, for example, a leg coming toward us is much too big relative to a hip further back. For this drawing, which was an early one, I first photographed a real girl with a wide-angled lens. I compensated for the distortions by trying to draw the body as it should appear to our natural eyes even though we were looking at it through a wide-angled lens. It can get terribly confusing.

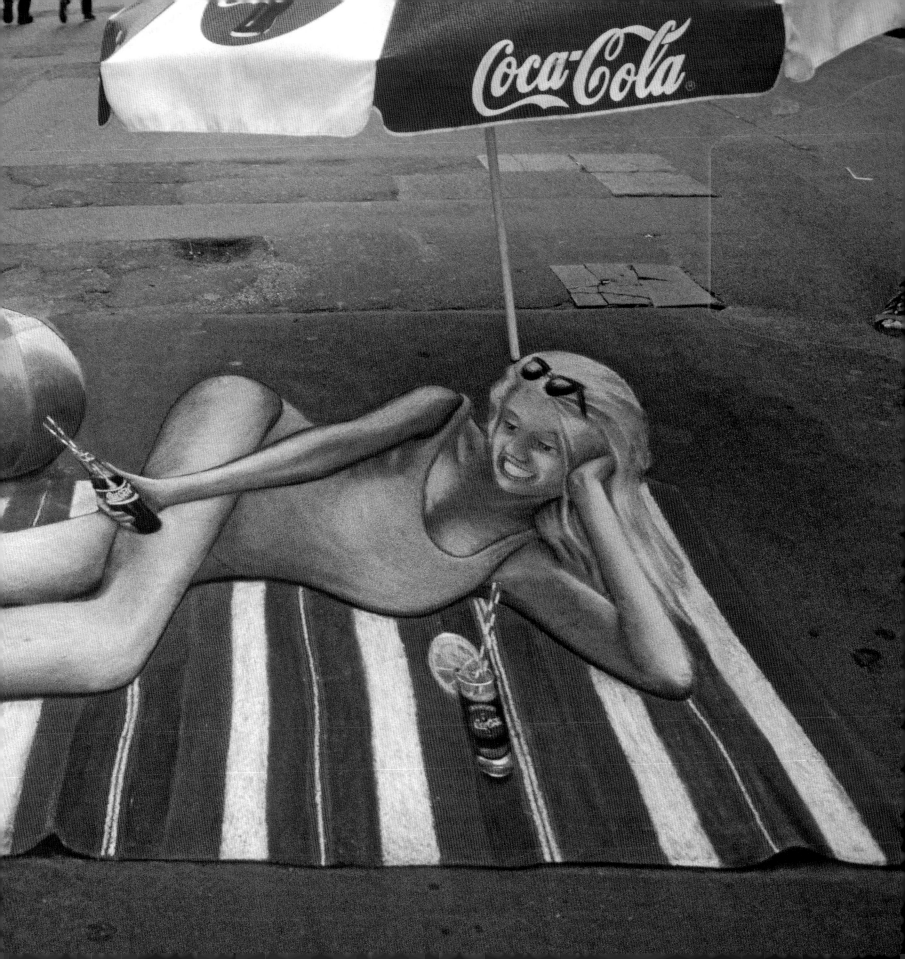

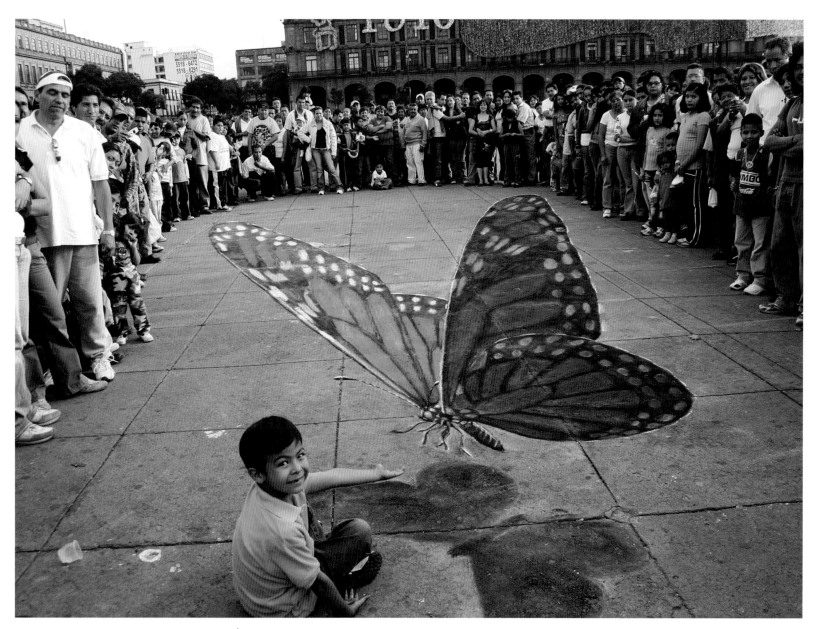

MEETING MADAME BUTTERFLY | MEXICO CITY, MEXICO

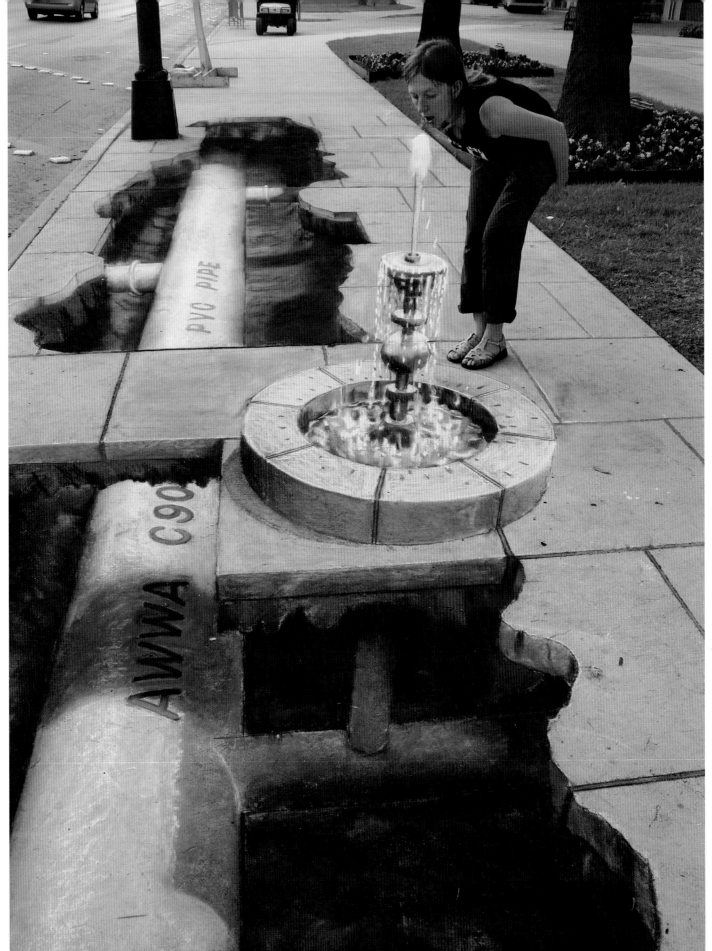

MEETING MADAME BUTTERFLY

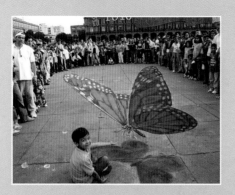

This drawing was made in Zocalo Square in Mexico City for the TV show "Concrete Canvas." The monarch butterfly follows a migration route down to Mexico every year and so I chose it as the subject of the only drawing I have done in that country. It was the first time I had tried to draw something in flight, that is, not in the pavement or on the pavement but above the pavement.

The key was to draw the shadow separated by space. I estimated the outline with a rope, and inside it I carefully filled in between the slabs to hide the joins. I then drew the wing veins in accordingly. I made a special effort to keep the under-wing dark so that I could give the upper wing its true brilliance.

Zocalo Square is said to be one of the largest in the world and fittingly this was one of my largest drawings. The crowd too was probably the largest I have ever had.

Another record was the number of visits the TV crew and I received at the site from the police. All the necessary work permits, filming permits and authorization had been painstakingly obtained in advance. Nevertheless, the police decided to stop by at least 15 times over a three-day period to question whether this was actually permissible. It was not hard to guess the motive for their tactics.

BENEATH EVERY STREET

This picture was drawn in San Antonio in over 100 degrees Fahrenheit (38 degrees Celcius). Only the shade of the trees made it possible.

I am sometimes asked if the straight lines made by the joins of the paving slabs help me construct the drawings. The answer is almost always no. These lines only remind the eye that what it is looking at is really a flat surface and I have to try to create an illusion by working against this. This is sometimes such a problem that I have to fill the joins in with a plaster mix.

However, when I am drawing a hole in the ground, they do serve the purpose of showing that the ground around the hole is, by contrast, flat. If there were no lines, the hole might seem to float in space.

This drawing was done on an ideal, continual concrete surface larger than the drawing. To strengthen the perception that the surface around the hole was flat, I drew in all the paving stone lines myself. This also meant that each slab could be drawn individually as it would have broken to leave the hole.

PAVEMENT CHALK ARTIST

BIG BEN

This picture was done in central London for the TV show "Concrete Canvas." We wanted something that the world would immediately associate with the city. In order to make a good link with the above-ground, real world and the drawn world below, I made use of this brick block at the side of the precinct. It allowed me to create the illusion of a ledge. From the beginning then, this determined the size of my clock tower: big!

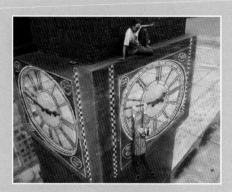

I got into difficulties with the circle of the clock. It had to be seen from above and so was to be seen as an ellipse. It also had to be seen from the side, and so it became a skewed, diagonal ellipse. And it had to be drawn on a horizontal surface to appear to be on a vertical face. And there were two of them . . . and the numerals had to be marked in correctly. I didn't use calculation on the first face, and struggled badly. On the second, I drew out a circle on paper and plotted a square grid over it. I then drew the same grid on the second face of the tower but in perspective, with all the vertical lines coming to a vanishing point under the camera. The horizontal lines were drawn parallel. I then plotted the circle back onto the grid.

EIFFEL TOWER SAND SCULPTURE

This image was drawn for our visit to Paris for the TV series "Concrete Canvas." The show's producers were refused permission for me to do the sidewalk drawing in every location they asked for in the city, so we had to do it a few miles out from the center in a place called St. Denis.

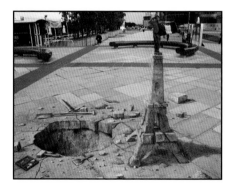

The idea of course was to present the sand sculpture as if it had been constructed from the materials dug out of the hole in the earth. The hole itself and the tower were the major parts of the drawing, and were done first. But it was all the small fragments of earth and soil spread around it (the *trompe l'oeil* effect) that really brought it to life.

My original plan for photographing the picture was to have someone next to the tower, quite close to us, placing a flag on the top. For this reason the tools, drawn lying about, were drawn to this scale. With hindsight, I wish I had done them smaller, to the size of the "little man" standing on the top.

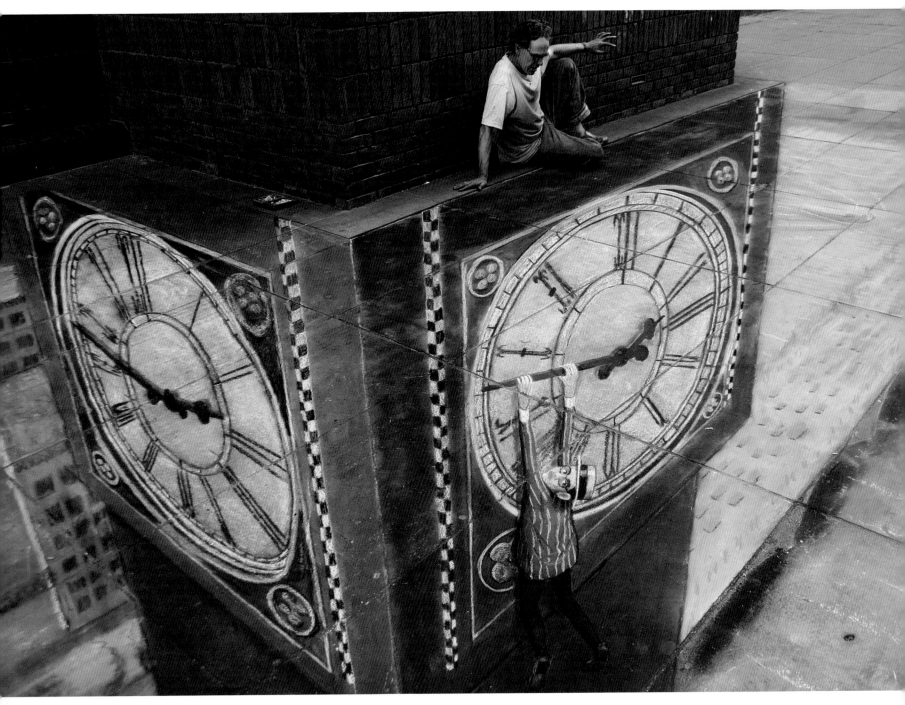

BIG BEN | LONDON, ENGLAND

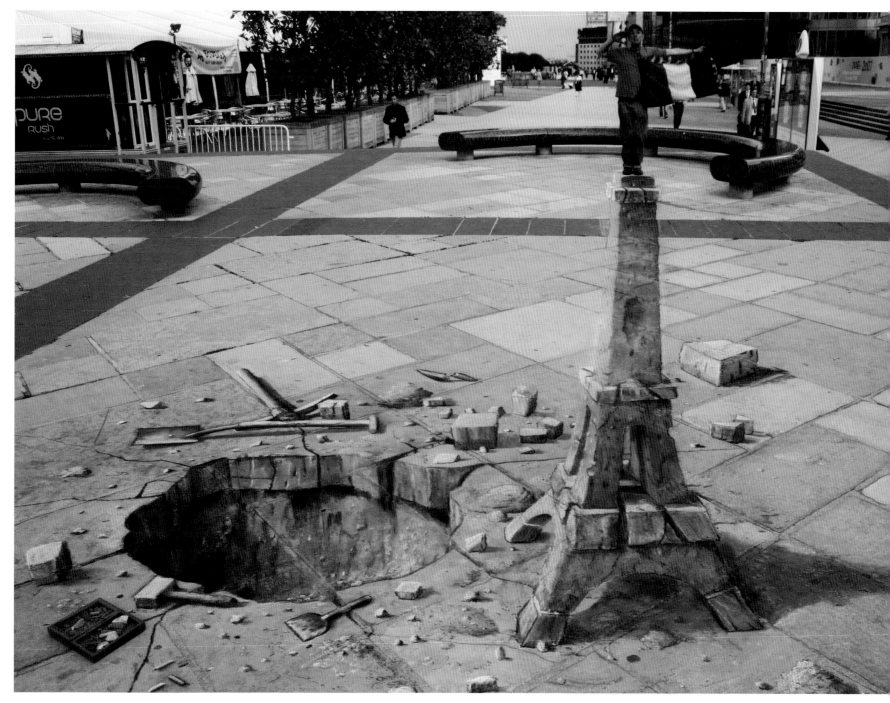

EIFFEL TOWER SAND SCULPTURE | PARIS, FRANCE

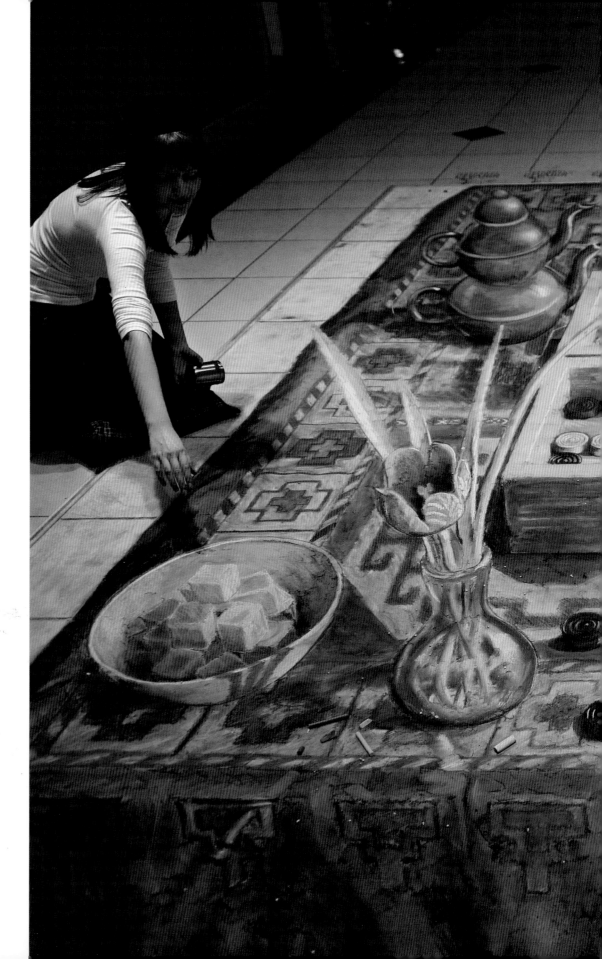

TURKISH DELIGHTS

ISTANBUL, TURKEY

This drawing, done in a shopping mall in Istanbul, shows a 2D surface with 3D objects arranged on it. It is essentially a glorified still life. Nevertheless, the Turkish rug had such a complex pattern that it was quite a job to get this finished on time. The pattern actually came from a carpet I bought at a flea market in Europe. If you look closely you will see that the buff-colored tiles on the sides of the rug are actually drawn to blend with the tiles of the mall floor. This was because the surface given to me was actually too big for the drawing as I intended it.

I would have liked the smoke from the Turkish hookah to rise away from the drawing. Because it all had to be kept within the prepared rectangle (the existing floor tiles being far too glossy to accept chalk), the smoke had to take a sideways path as if in an air stream. This is one reason I prefer to work on real floors or sidewalks. They allow you to take extensions off and out of your main area into the background.

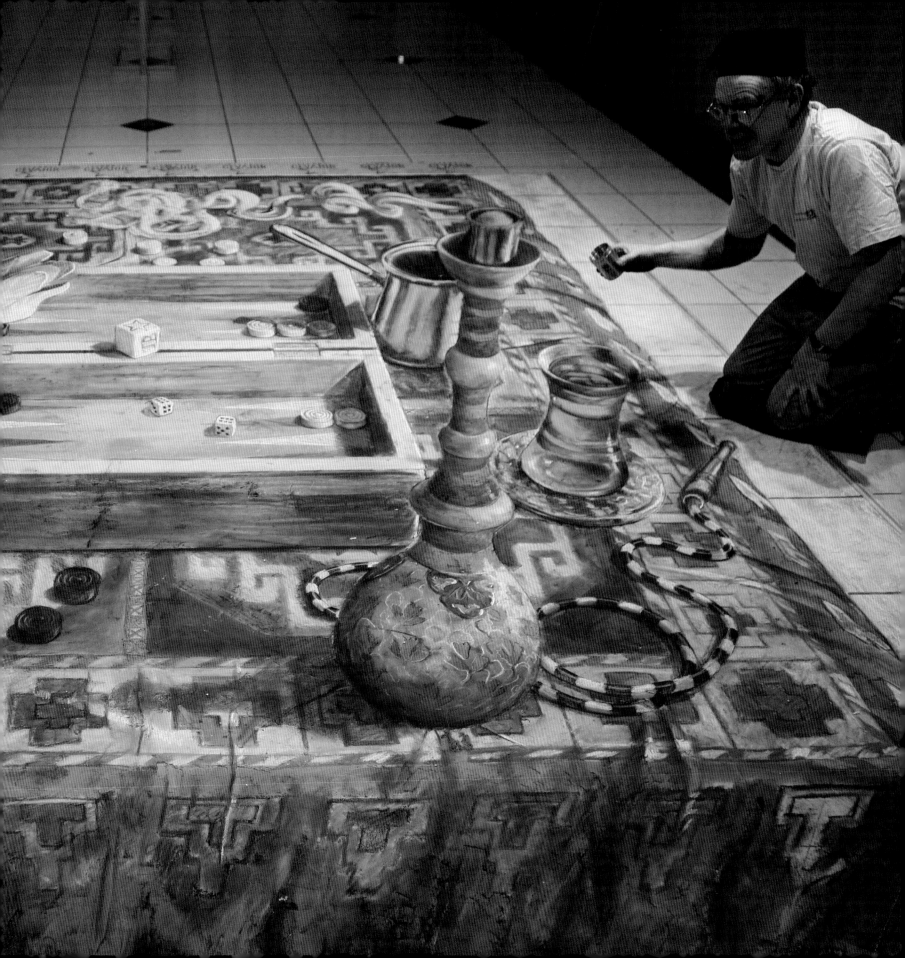

COOKING THE PIZZA

MONTREAL, QUEBEC

This drawing, done in Montreal, presented two challenges: drawing the larger part of the drawing as a vertical plane (when it was really on a horizontal plane); and creating the feeling of the emanation of intense light and heat coming out of the oven.

The horizontal rows of bricks, or more precisely the rows of mortar between the bricks, had to be carefully considered. To do this I arranged pieces of chalk at equal intervals along the side of my drawing. Those that were further away from me appeared through the camera lens to be closer together. I then had to go back and forth to the camera to space them one at a time so that they would appear to be the same distance apart from one another. This meant that those that were further away actually had to be further and further apart. When they appeared correctly spaced, I marked each one and then drew each line of horizontal mortar.

The vertical lines of mortar between the bricks were drawn using an anchor point under the camera. Of course these are drawn every second row of bricks.

I visited several pizzerias with digital camera in hand before I went to Montreal. As I had expected, the camera gave two main results. Either the flames were shot at the correct exposure, making the outside of the oven look almost invisibly dark; or the outside of the oven was shot at the correct exposure, making the oven interior appear dazzlingly bright without any detail.

I wanted to draw the oven more like the second version, but nevertheless manage to show some detail and color. The outside of the oven was drawn dark, but not overly so. I think my ambitions were reasonably well achieved.

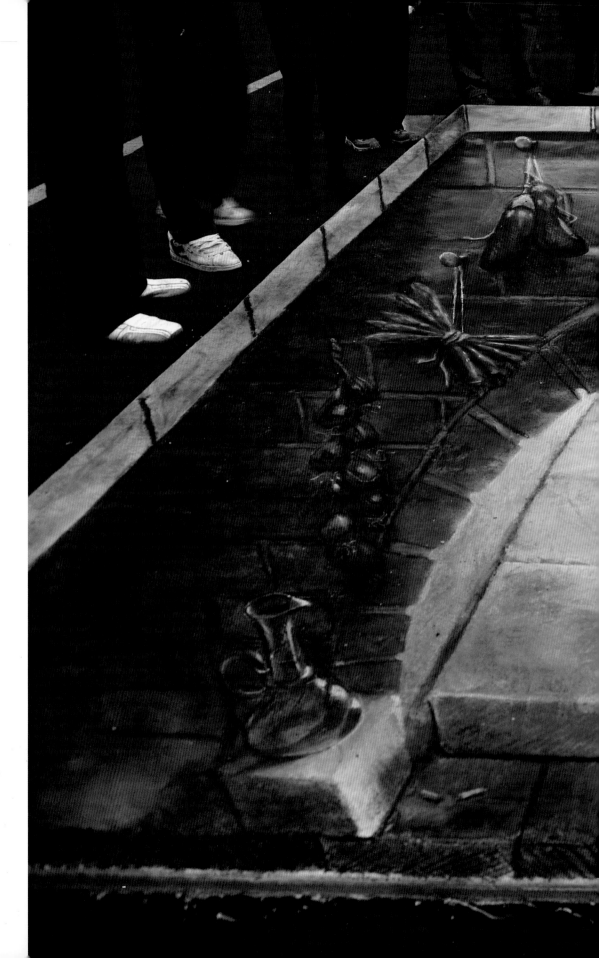

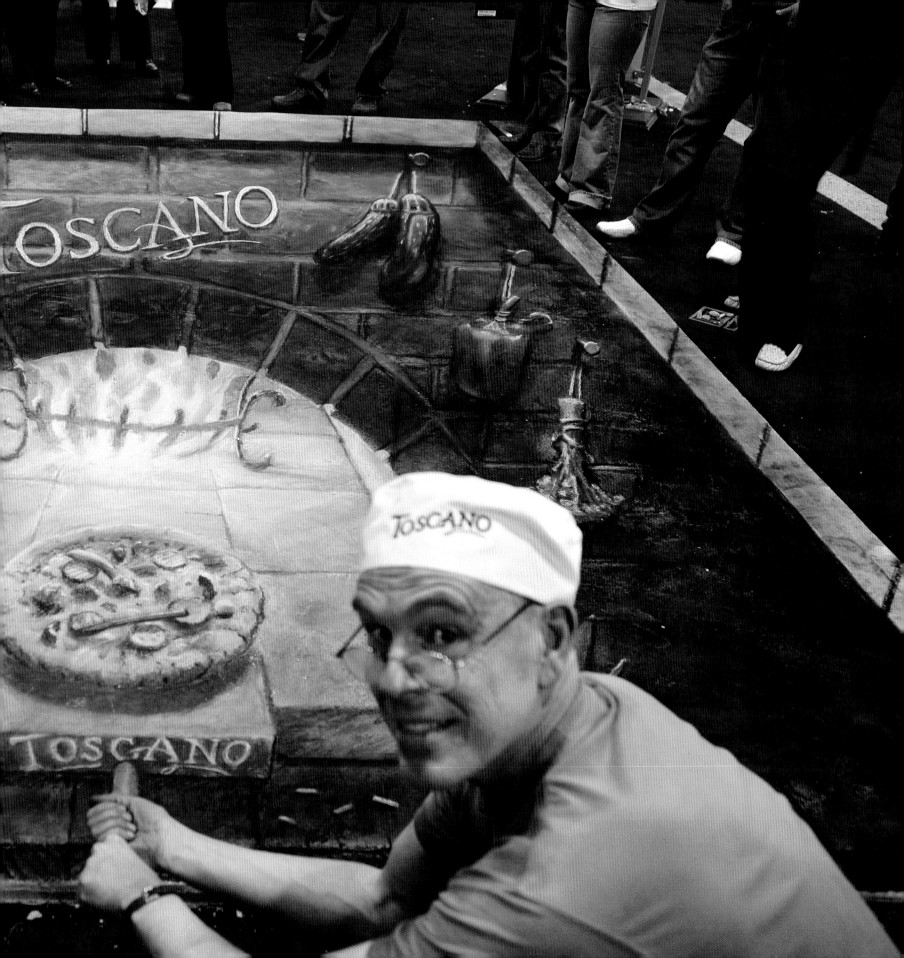

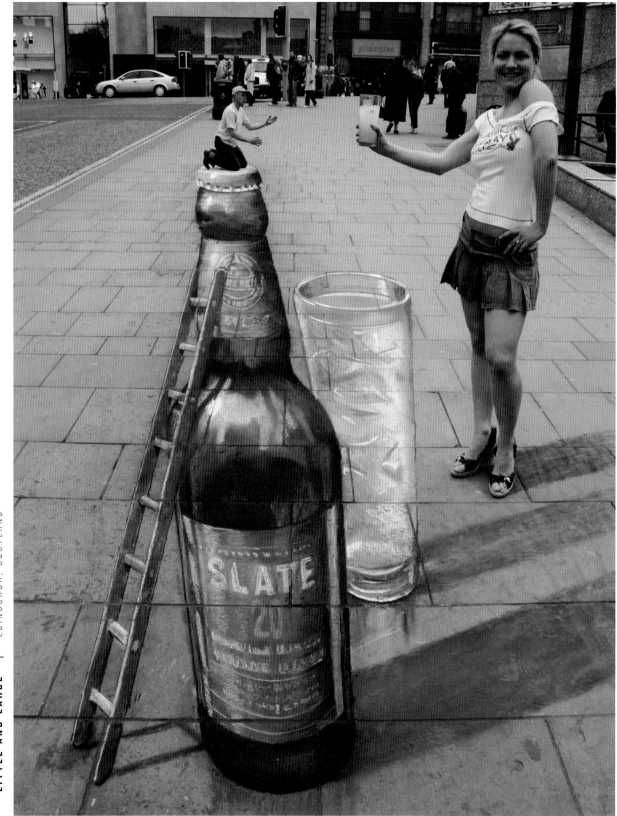

LITTLE AND LARGE | EDINBURGH, SCOTLAND

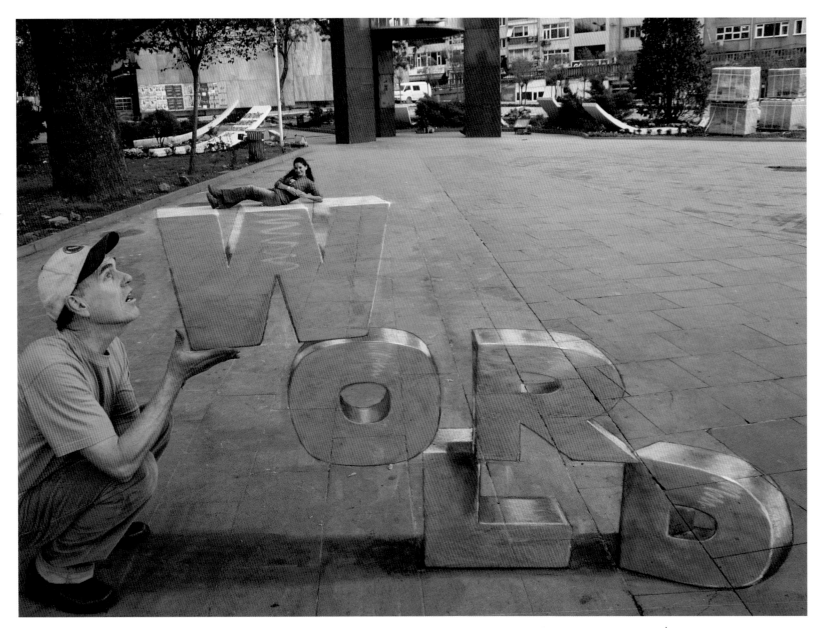

LITTLE AND LARGE

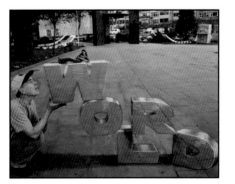

This drawing was done in the same spot in Edinburgh as the *Globe* drawing, *Make Poverty History*, which I had done several months before, and was inspired by it. For that earlier drawing I positioned myself on top of the globe to create the illusion that I was holding a rope that was lifting a banner. But when I looked at the photos later I realized that in placing myself on the top of a very tall-looking object (which in reality receded a long way on the ground), I looked absurdly small in relation to the other people who were nearer to the camera. (See the *World Card* drawing text for a fuller explanation of this phenomenon.)

One reason for choosing this spot was that it was on a steep slope, which allowed quite a tall object to be created without my having to go back a long way to draw it. In other words, my canvas was made higher

It is always a good idea to take the subject of your drawing, in this case the bottle, with you to see how it looks at the site. Here I placed the bottle on the sidewalk and made close reference to it. In particular, the reflection of the sky with the silhouette of the buildings was authentic. The ladder was added to match the scale of the "little man" on the top and of course to explain how he got up there.

WORLD CARD

It is interesting how one drawing can lead to another. This drawing, featuring what I call the big man/little man effect, came about after I had achieved the same kind of effect in the earlier drawing *Little and Large*. That in turn came about because of my accidental discovery of the effect in the *Make Poverty History* drawing.

To achieve this effect I draw what looks like a standing vertical object on the horizontal sidewalk. The top of the object is naturally further back on the sidewalk than the bottom. Anyone standing at this further-back position appears smaller to the eye than a person standing near the bottom because of the fundamental effect of perspective, that is, the fact that objects appear smaller as they get further away.

Our brains use a mechanism known as size constancy, which automatically judges the distances, allows for the perceived difference in size and so by calculation tells us the actual size of both persons. This is so common that we take it for granted. But if we draw what looks like a vertical object that appears to be as close at the top as it is at the bottom, the brain is tricked. It makes us think that the person posed "on the top" of the object really is as small as they look.

OH CRUMBS! WHALE IN SALAMANCA

For this drawing at a street festival in Spain I was in the fortunate position of being able to choose whatever subject I wanted. I made use of my earlier experience in drawing *Arctic Street Conditions with Soft Drink*. This time I expanded it to cover a wider area and included large pieces of floating ice.

Some drawings stand on their own. Others, like this one, are only complete when photographed with a person posed in them. Notice that the slab of ice I am sitting on is leaning to take my weight and the strain that the whale is putting on it. I quite like that bit.

Although I love doing it, drawing water is for me a tricky and uncertain business. Sometimes it works immediately; other times it doesn't. It was only when I looked at photos after the event that I decided that this one wasn't so bad. I wish I had put more water pouring off the whale's flukes. I made sure to do so on my later sea drawing, *Catching Crabs*.

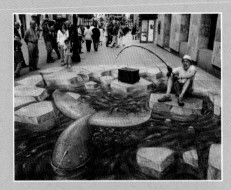

TAKING THE PLUNGE

This picture, together with *Beneath Every Carpark*, was done at the Just for Laughs Festival in Montreal. While that one made a good use of the horizontal landscape camera, this one is a good example of an instance when the portrait position is better. It gives more up-and-down space to draw in and less side-to-side. It also means the camera can get much closer to the foreground so as to exaggerate the size differences between close and far.

The drawing was done not long after *Batman and Robin* and built on my discovery of the benefits of a wall in expanding a drawing. The organizers had sent me photos of possible locations, and this one with the steps at the back automatically suggested a waterfall.

I had noted how the woodwork in harbors is always dark or green as it is overgrown with algae below the waterline.

I took care to put a slight bend in the end of the diving board to suggest it was taking some weight. This is a good example of a drawing that, without a real interactive person, is not only incomplete but meaningless.

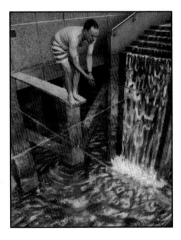

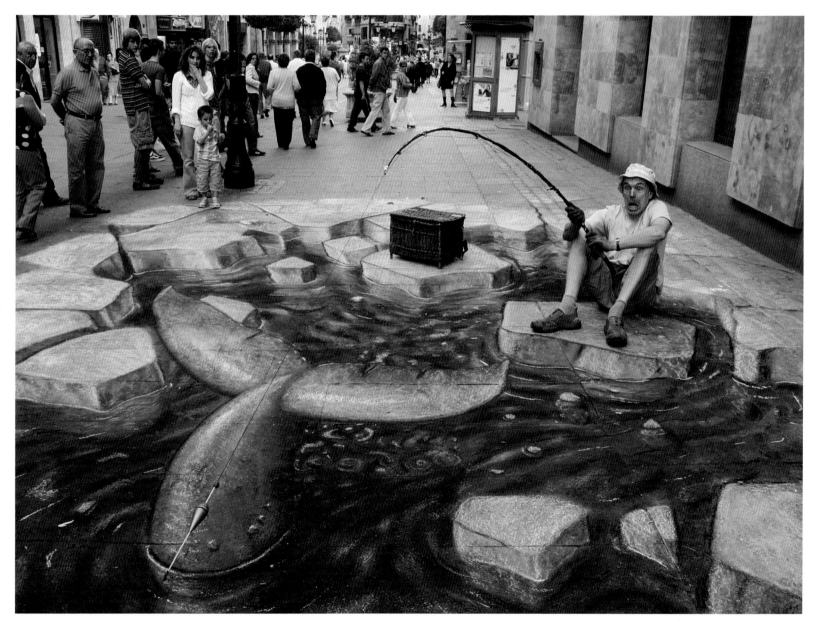

OH CRUMBS! WHALE IN SALAMANCA | SALAMANCA, SPAIN

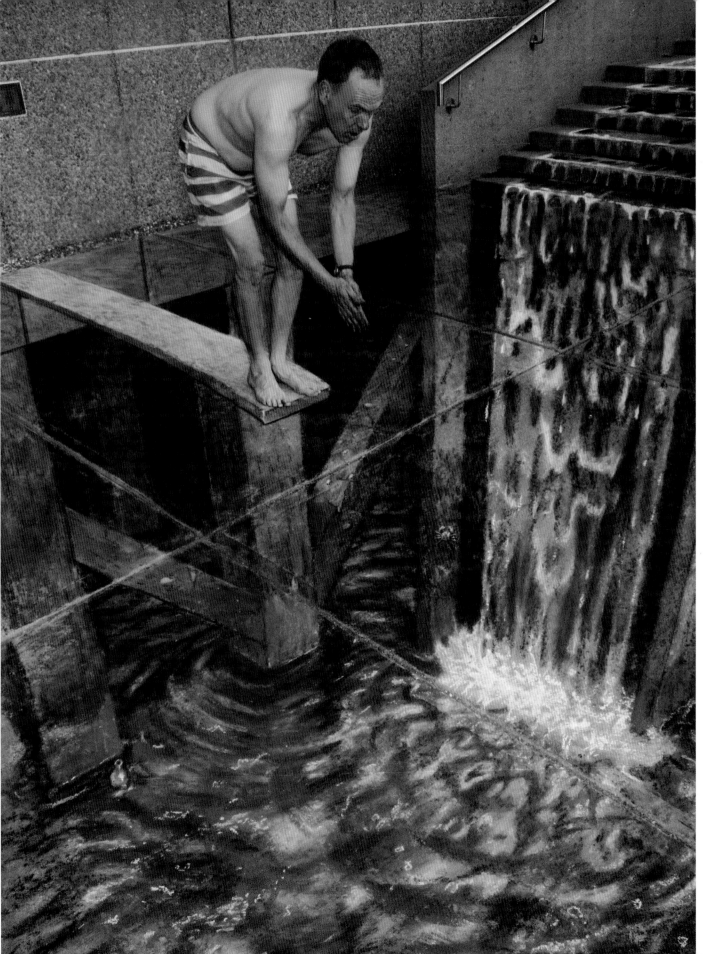

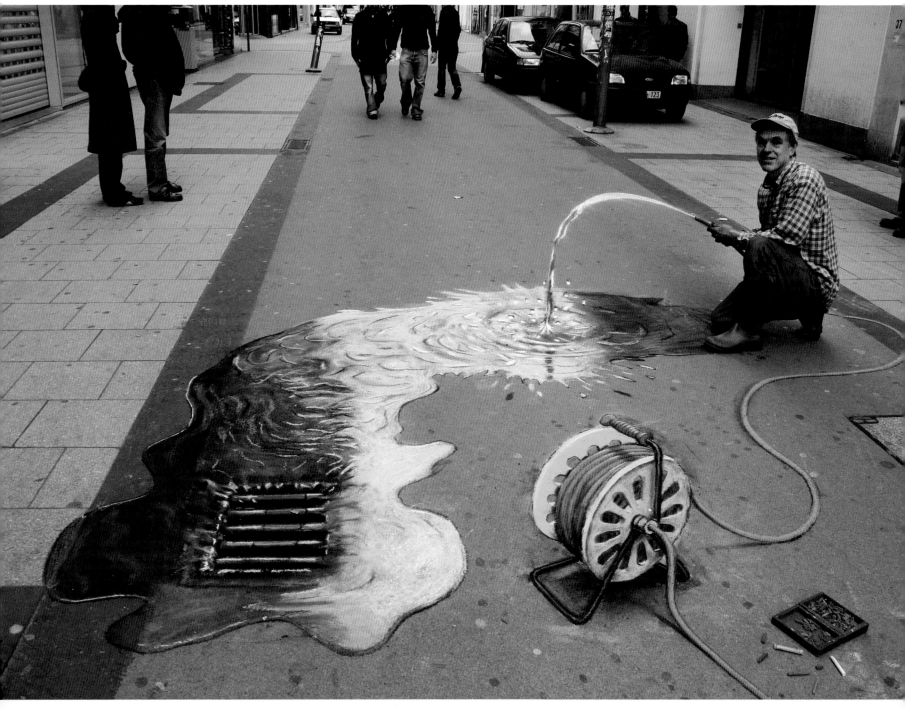

WASTE OF WATER | BRUSSELS, BELGIUM

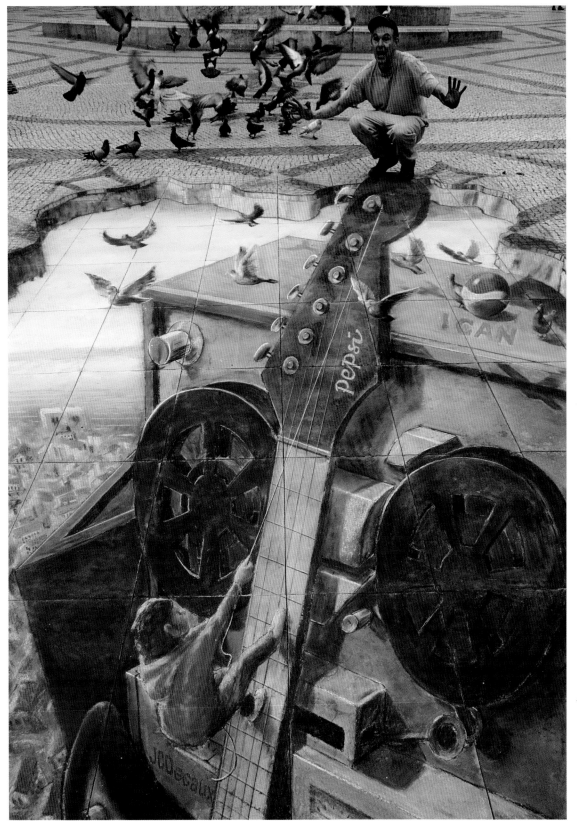

WASTE OF WATER

The title for this piece came about when I showed it to my girlfriend's grandfather and he said, "What's that? A waste of water?"

Actually it was never meant to be a comment about wastage. It was simply a drawing that allowed me to play with illusions of water in various forms: a jet, a splash and running flat over the pavement. These contrast with the solid standing object of the hose coil and its holder. All parts link in a circle.

In fact, the drawing of the hose coil was by far the hardest part. I used a roller for an electric extension cable and mounted it on a block so that it corresponded to the position I wanted it when seen through the tripod-mounted camera. I then went back and forth drawing its outline in white chalk so that these lines appeared around the edges of the object in my view. I redrew the outline in black and colored it in.

I later had an email from a scientifically minded critic who told me that this drawing was incorrect because the curvature on the water jet should be exactly equal and symmetrical on both sides of its highest point. I answered that he was right, supposing that the water was jetting at a constant rate from the hose, whereas my jet, obviously, was jetting out at a variable rate!

PEPSI I CAN

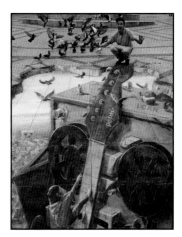

This was commissioned by Pepsi, through FUSE® an OmnicomMediaGroup company, and drawn in Lisbon to support one of their TV advertising campaigns. The teenager climbing up a stack of sound equipment was taken directly from the television advertisement.

What pleased me most about with this picture was the way I managed to create an irregular fractured edge to the hole in the ground. Lisbon's sidewalks are almost entirely composed of very small square buff-colored flint bricklets that are hopeless for drawing on with chalks. It was necessary to lay down cement paving slabs over the flints. The problem then became how to hide this fact and make the illusion appear to be set in the real sidewalk. What I did was to draw my own flint tiles around the edge, carefully color-matched so that my actual rectangular edge is not seen.

Although the plan was always to include pigeons flying off the tape player (to give a reminder of scale and a feeling of freedom), by luck the location had its own teeming bird population. I like this shot because not only the edges but the birds, too, blend drawing with reality.

BABY FOOD

This drawing was done in Hartlepool, a fishing town in the north of England, hence the seafood theme. My progress was followed from start to finish by the BBC's children's art show "Smart." I had fun directing the presenter further and further back along the sidewalk as she helped me mark in the lobster's long tentacles. Visitors were able to pose on the bowl and have their photo taken for posterity.

I think the interplay between the lobster's bizarre coloration and the reflection that comes off its armor plating works well. I should perhaps have filled some of the paving stone joins, which are a bit more visible than I would like, on the bowl particularly.

I expected more complaints when I posted this on my website of drawings, but surprising there have been very few. It shouldn't be taken too seriously.

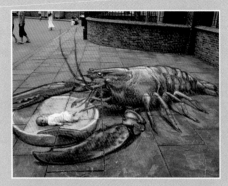

CATCHING CRABS

This is one of the drawings I am most pleased with. It confirms my belief that drawing a small thing big is better than doing a big thing small. To be more precise, the crab on the ground wasn't actually all that big because it was near the camera. The point is that it appears big compared to all the things that appear small in the distance.

When I did this drawing I realized that if there is an overriding theme that unites all my drawings, it could be childhood wonder. I remember my heart stopping the first time I pulled a crab out of the sea when on holiday as a boy with my brother. I recalled that same feeling when I was working on this drawing in Porto.

I had used a very similar backdrop of wooden harborfront moorings in *Taking the Plunge*. I made sure to show the water dripping off the crab after learning my lesson when I failed to do so in *Oh Crumbs!*, the whale drawing. From my earlier drawing *Baby Food* I knew that crustaceans make good subjects.

I added the seagull to increase the grand scale of the crab (by comparison). The bird not only raises its wings and opens its beak in alarm, but the telltale stream behind it illustrates the alarm it must have felt upon seeing the giant beast emerge.

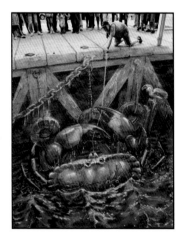

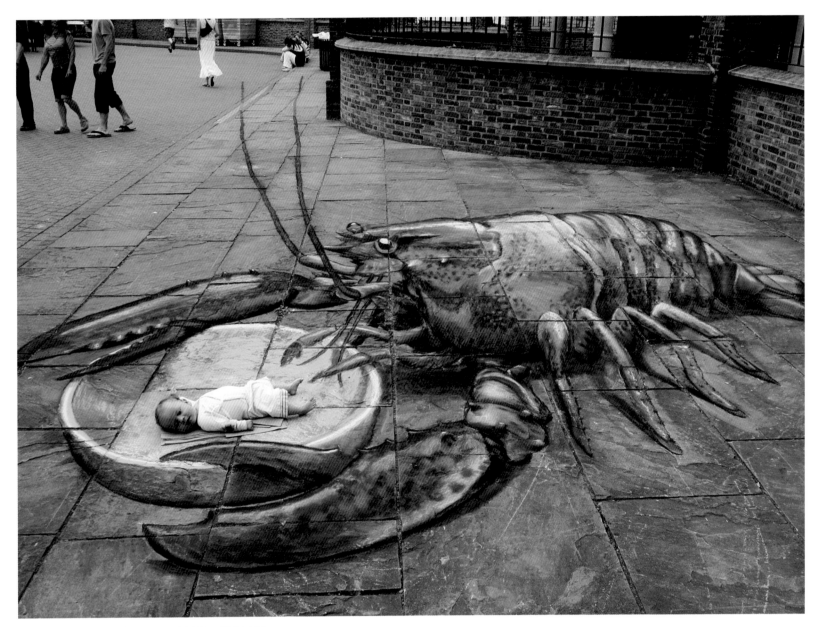

BABY FOOD | HARTLEPOOL, ENGLAND

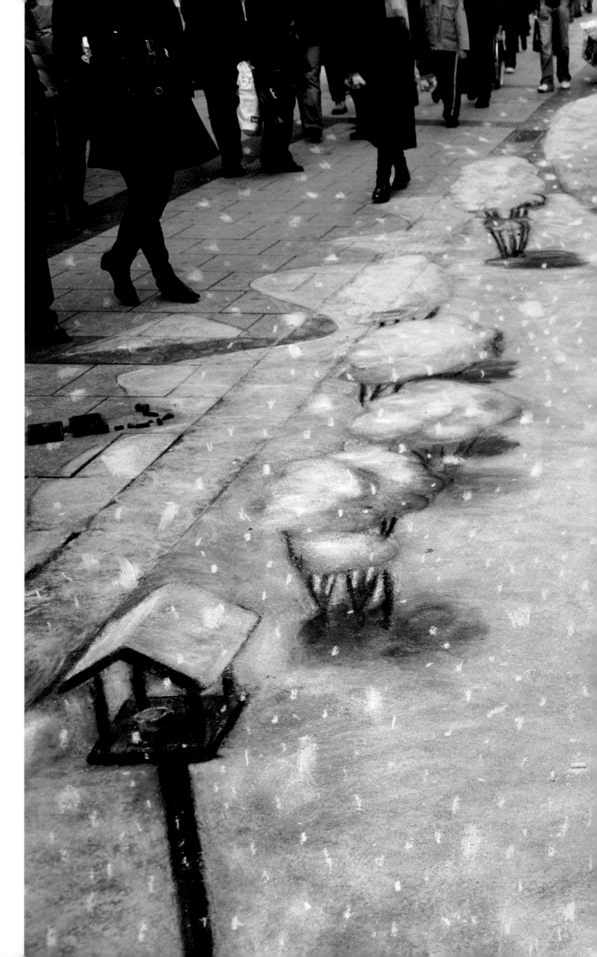

MAKING MR. SNOWMAN

BRUSSELS, BELGIUM

This drawing was done just before Christmas in Brussels, and was published in the *Daily Mail* in the UK.

The snowball in the distance was drawn as a very long oval in order to appear round at that distance. It was longer than all the rest combined. The snow on the ground was achieved using flour sprinklers, and light gray-blue powder was rubbed in with foam.

The drawing was not technically demanding, since there were no complex shapes or detailed parts. However there was a lot of ground to cover and it demanded stamina in the cold weather, especially from my junior helpers, my daughter and her cousin, who had to hang around a long time in the cold while the picture was worked on.

Ironically the biggest threat to this picture's completion was the risk of snow itself.

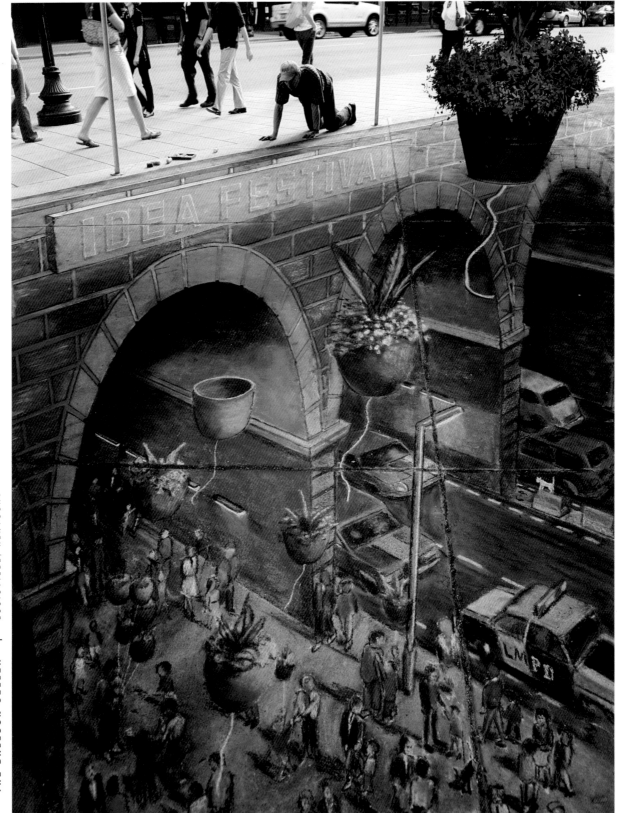

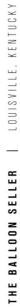

THE BALLOON SELLER | LOUISVILLE, KENTUCKY

BENEATH EVERY PARKING LOT | MONTREAL, QUEBEC

THE BALLOON SELLER

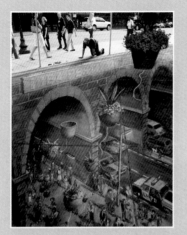

For this drawing, done at the IdeaFestival in Louisville, Kentucky, I used one of the flower vases that stood outside the main event. It is always fun to try to incorporate real objects into drawings, to confuse the eye as to what is real and what is not. My idea was that the vase of flowers would double as one of the fancy balloons that the vendor was selling down below.

Although I consider it partially successful, problems arose because the drawing had to be photographed under artificial light. While the even light was effective on the flat chalk surface, the flower vase, which of course was three-dimensional, had a strong shadow compared to the other balloons and the similarity was reduced.

By bad luck the entire four days I was there were rainy, with storms forecast. We had an ongoing battle with encroaching water, which could only be held off — to limited effect — with a long defensive line of sandbags.

Perhaps more than most, this image shows the difference between the texture of the drawing close to the camera and the drawing far away. Even though the figures below were carefully executed, they still appear quite crude because at this close distance every grain of chalk is visible. In the distance, however, the lettering, which was drawn very roughly, appears neat and crisp.

BENEATH EVERY PARKING LOT

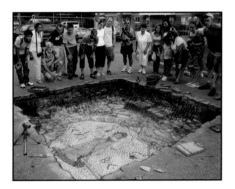

I enjoyed doing this drawing. It was one I had had in mind for a long time. I had always thought it could be done as an advertisement uncovering some ancient hidden logo for a modern product, but in the end I did it at the Montreal Just for Laughs Festival with no product to push. Much better!

For drawings demanding an illusion of height it is often best to position the camera in vertical "portrait" position. This is becoming more and more my norm. But for this low-relief illusion, I wanted more width than depth and opted for the camera in "landscape." Sometimes an attempt to trick the eye into believing a small lie — that there is a shallow hole — can be more convincing than trying to make it believe in a big lie — that there is a very deep one. This one seemed to work well, not least because I had ample time to concentrate on the detail.

I wanted to do this drawing in part in memory of my father, who was an amateur archeologist in his later years, and the kind of tools seen lying around here were typical of those in his garage. Archeological scholars will be impressed by the authenticity of the mosaic as an antiquity and in particular with the date 211 BC embedded in the mosaic.

NOKIA CITYSCAPE

When it rains in Singapore it rains! For this reason the organizers of the event erected a large and splendid tent for me to work in. This drawing, commissioned by Nokia, was meant to be a modern cityscape of colorful office blocks that doubled as mobile phones. All went well until the second day, when the skies darkened and flashes of lightning announced ferocious thunderclaps. I carried on working, dry beneath my tent, listening as the raindrops grew ever bigger. Then the tent started shaking as the wind rose higher. Suddenly it turned over and the entire structure cartwheeled out of control across the street.

I was drenched and the entire drawing was flooded under an inch of water. The rest of the day was mostly lost and a long mopping and drying process followed. After an event like that it takes all one's courage to start again at double speed to make up for lost time.

It is a departure from my earlier anamorphics, as it is as much concerned with light and movement as it is with purely 3D form.

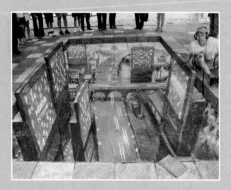

FELIX CELEBRATES CHINESE NEW YEAR

This piece was done just outside the Chinese quarter in Birmingham, England. The idea was that the cheeky cat always gets into mischief and wanted to get in on the act of the Chinese New Year carnival.

Although the surface was a little too shiny, I was nevertheless able to get a good deep black for the inside of the hole, which is really necessary to give the effect of a deep void below.

This was an early drawing and I had no tent over my work. To protect it at night I used my old system from busking days. This was first to cover the picture with flat cardboard, place a few cardboard boxes on top and then throw a large plastic sheet over the entire thing and tape it down with gaffer tape around the edge. As long as the rain isn't too heavy and vandals leave it alone, this is usually good enough to protect most of it.

It may seem unlikely that a pavement drawing would come over very well on radio but the BBC World Service and local radio both covered this event.

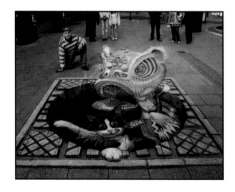

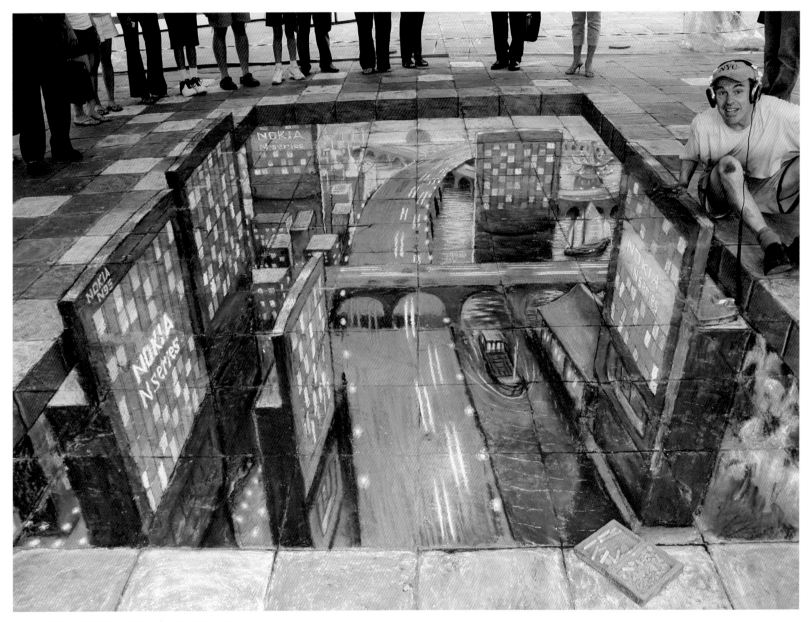

NOKIA CITYSCAPE | SINGAPORE

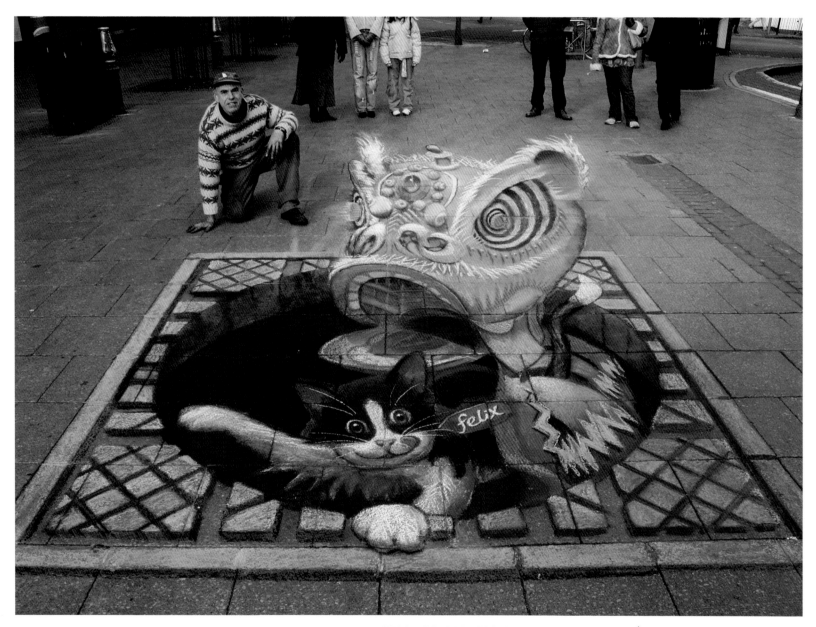

FELIX CELEBRATES CHINESE NEW YEAR | BIRMINGHAM, ENGLAND

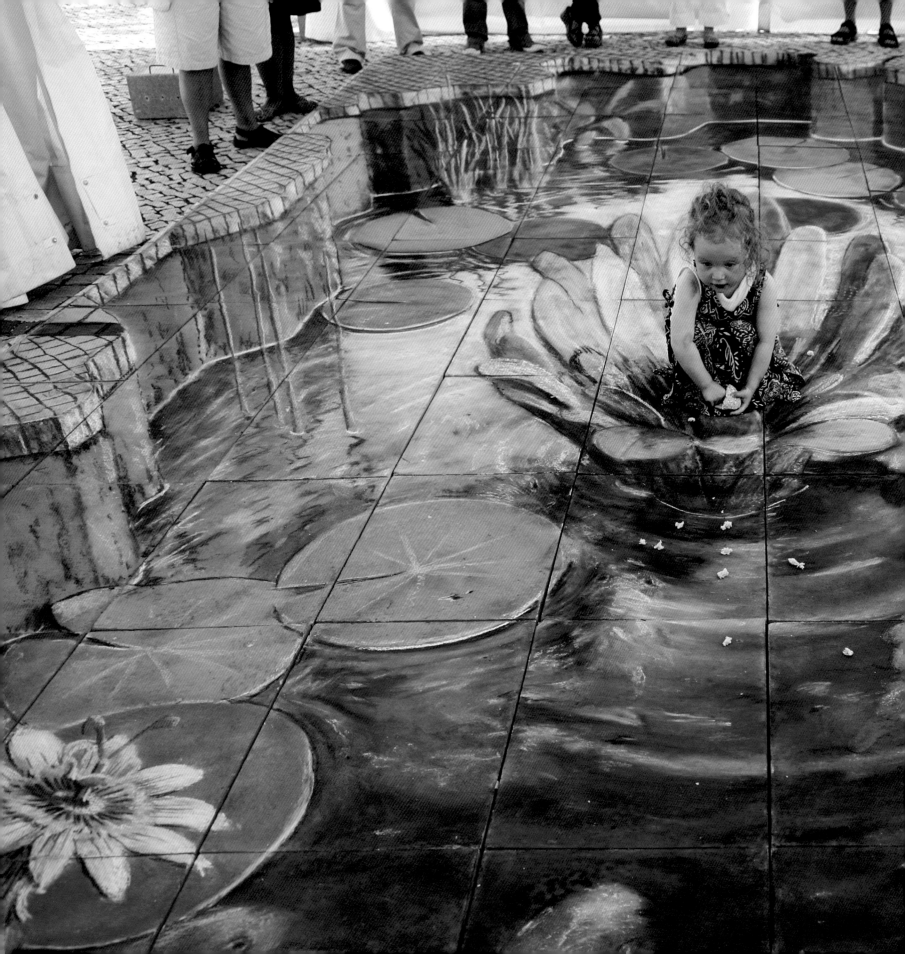

FEEDING THE FISH

LISBON, PORTUGAL

I have now created drawings in countries all over the world, including cities in South America and Asia. This drawing, done in Lisbon, was the hottest one ever, with temperatures over 100 degrees Fahrenheit (38 degrees Celsius). A protective plastic tent had been erected over it to give sun and nighttime protection, but the tent also acted as a greenhouse. As I knelt over the picture, sweat was literally dripping down onto my hands and chalks.

The original plan for this drawing had been that a model actress from a Portuguese TV soap opera would pose on the lily flower to promote a beauty product. But secretly, I always wanted to photograph it with my little daughter as the star. I like having children in my drawings. Apart from bringing innocence and childhood wonder to a piece, they help the sense of scale because they are small. By comparison they make a drawing seem big!

What I most enjoyed in this picture was drawing the fish broken and warped by the effect of the rippled water. I much prefer drawing things that allow freedom of movement as opposed to geometric exact things, which need calculation and leave no margin for error.

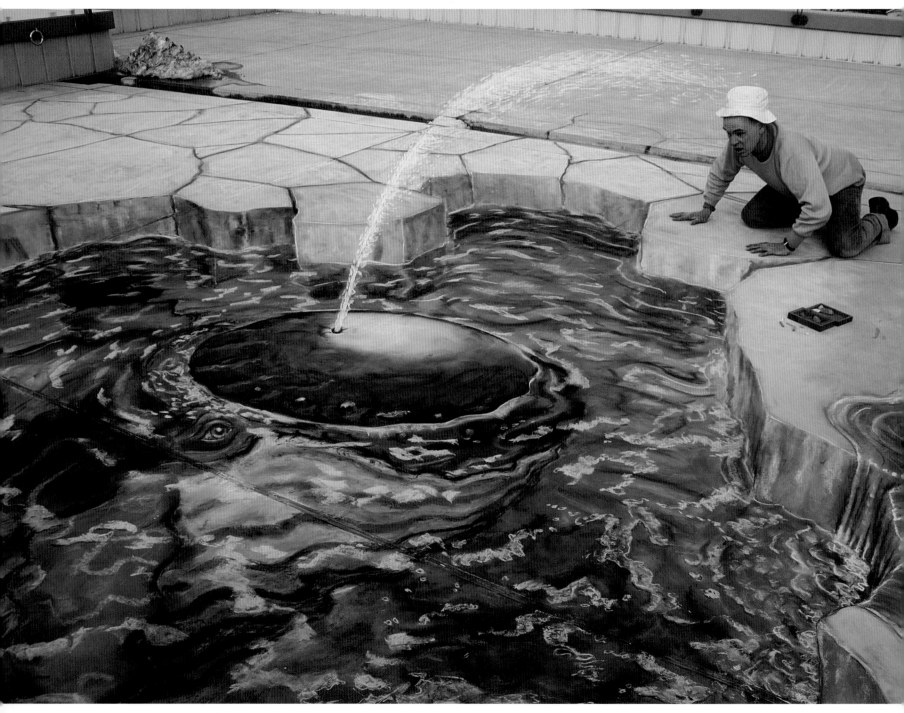

LET'S BE FRIENDS | TOKYO, JAPAN

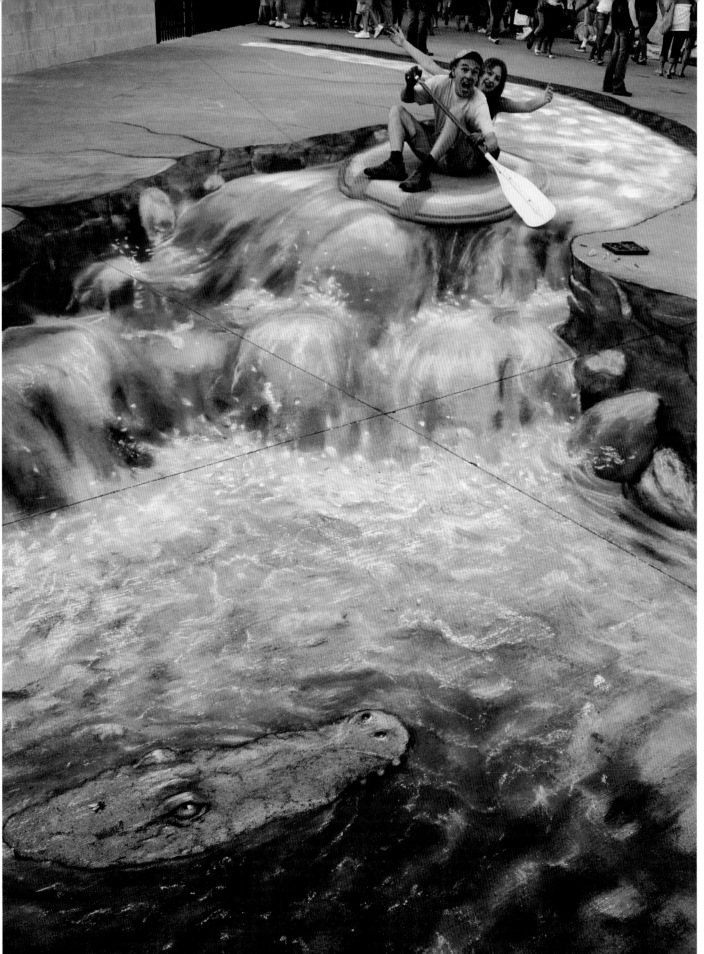

LET'S BE FRIENDS

This whale was drawn at a film studio in Japan and was featured on a prime time TV show called "Unbelievable." It was done in cold January temperatures and had to be protected from snow at night by an extensive plastic sheet. A small heap of melting snow is just visible.

In my travels worldwide sunlight and heat most often pose the greater problem. I prefer working in the cold; making a drawing of this size usually requires so much energy that winter clothes actually are not always needed.

I love the challenge of water surfaces where I can interplay the view below the surface and the reflections of surroundings and the sky above.

WHITE WATER RAFTING

This drawing was done in Charleston, West Virginia, for the town's art festival. White water rafting is one of the local attractions.

I first marked out the banks of the river, then considered how the water might flow through this space. Although the course of the water looks chaotic, it nevertheless had to be composed so that it appeared to be cascading downward in a natural way. It was interesting to draw agitated water that you cannot see far into; far from being transparent, the oxygen-filled water appears a bluey-green. Although the crocodile appears enormous it is only its closeness to the camera that creates that impression.

I first drew the raft in a gray color, wanting to avoid making this picture seem in any way gaudy. However, it didn't stand out and so I washed off the gray with water, allowed it to dry out, and redid it in yellow, making it much more the center of attention. Compositionally this made a link with the yellow eye of the croc.

A local visitor kindly provided the paddle, which, as the only prop, made the picture complete. The freedom to extend a drawing back as far as this is one reason I love working on sidewalks. This was one of the longest I have done.

PAVEMENT CHALK ARTIST

TAKING THE DELIVERY IN LONDON

The idea for this drawing is that we see a parcel being delivered by courier mail from the other side of the world, China, which is of course upside down. I was asked to use some of the imagery from an existing campaign.

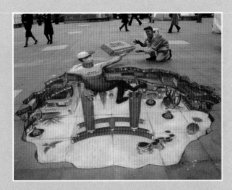

I feel this picture was a struggle for a number of reasons. I am always wary of drawing buildings. It is hard to give them the kind of photographic realism they need because they are often so detailed and strictly regular in their shapes. The sky effect was undermined because the edges of the sidewalk slabs were all too apparent. If time had permitted I would have filled these lines with a plaster mix, but even then it is hard to completely hide such lines, especially when they are near the camera.

I drew this picture as if the sidewalk had two surfaces: one in the western hemisphere and another below opposite and upside down so that we could see some brickwork between the two. One puzzle was whether the brickwork should be lit from above or from the Chinese world. In the end I made the decision to sidelight it, as this is usually the best way to make something appear 3D.

RESCUE

This was an early drawing done in Brussels during my experimental period.

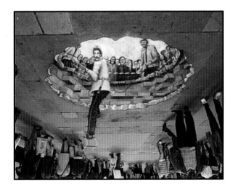

I found a way to mount the camera on a tripod looking down on an upward-sloping mirror — so that I could see the street upside down. It was the first drawing I ever did of a hole going through to the "other side."

I found it more difficult than I expected to keep the brickwork in perspective in the "in between" zone. Here I encountered the question of whether the bricks and the edges of the hole should be lit from above — the real world, or below — the drawn world.

Although there are some weaknesses in it, I look back on this drawing with affection. If nothing else, I think it is one of my most original.

It was done long before I got commercial commissions. Few passers-by understood what it was about, and not many troubled to look through the camera. I can now look back with a smile on the fact that it earned twice nothing in the hats!

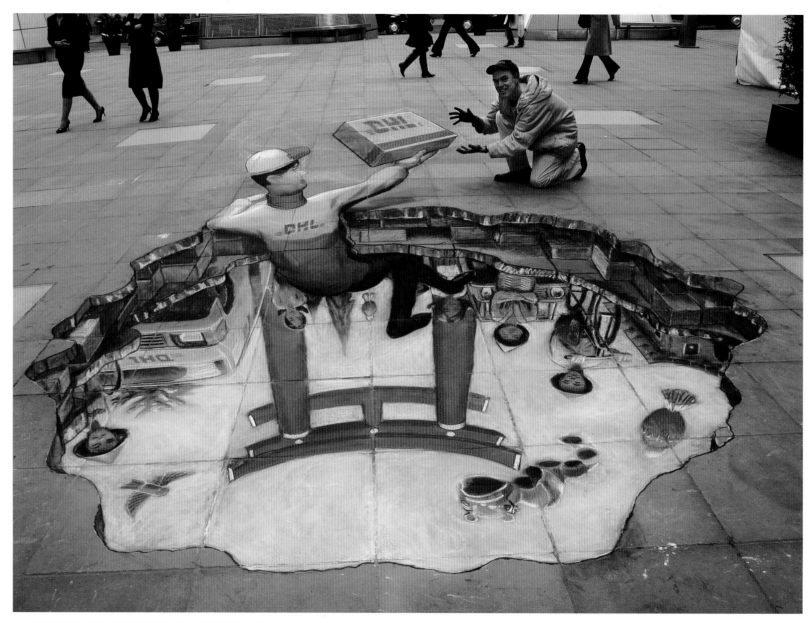

TAKING THE DELIVERY IN LONDON | LONDON, ENGLAND

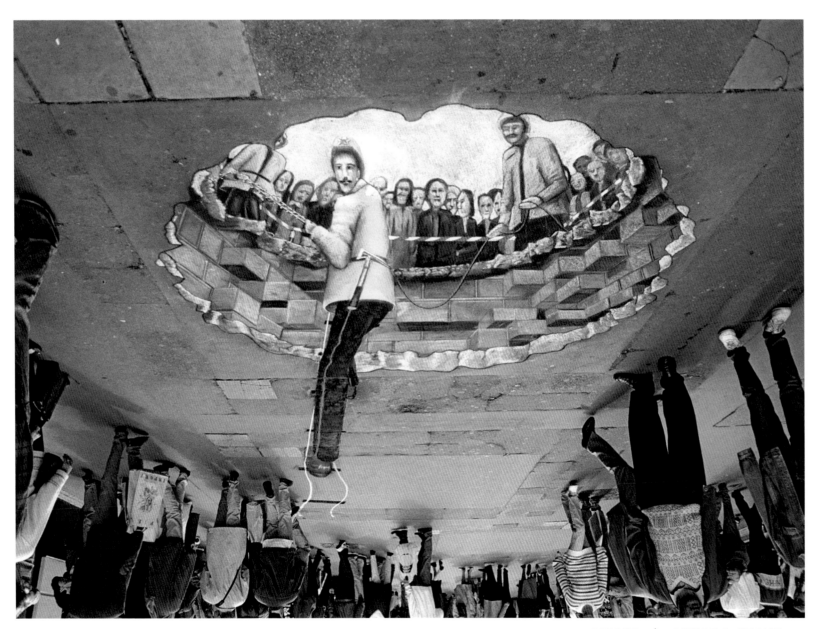

RESCUE | BRUSSELS, BELGIUM

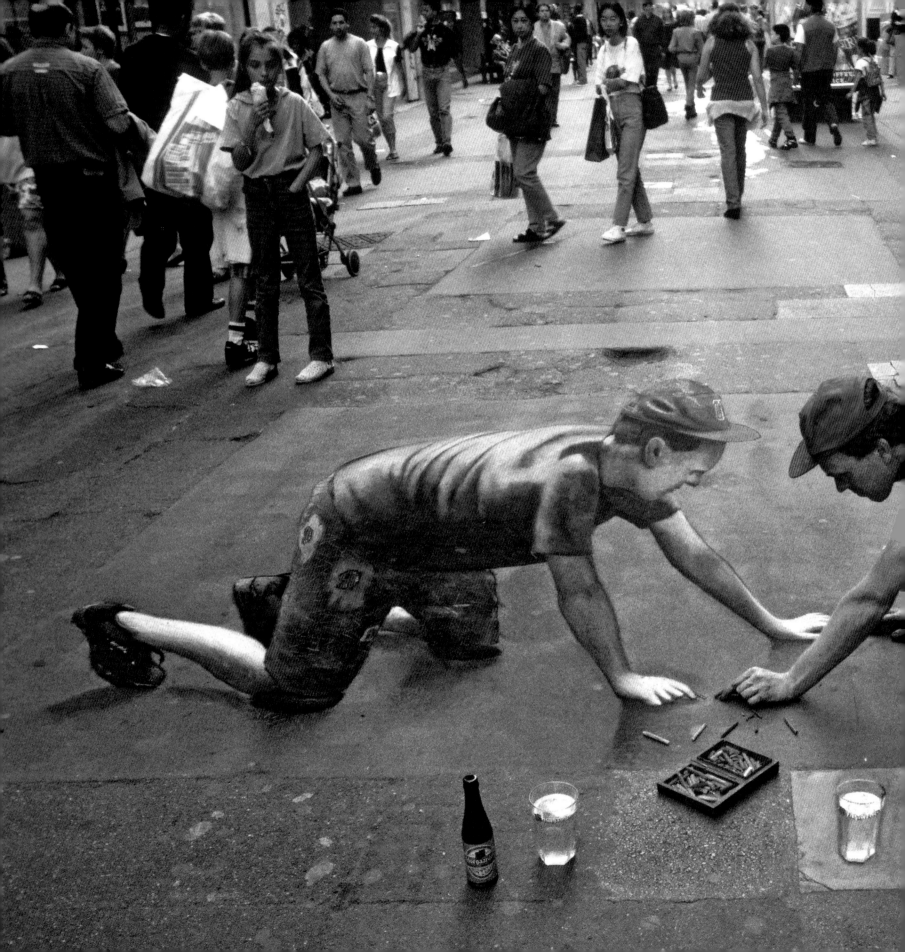

SELF PORTRAIT WITH LIQUID REFRESHMENT

BRUSSELS, BELGIUM

This was one of my early experiments and was made with an eye to getting commissions. In searching for subjects, I asked myself what sort of things might be found on a pedestrian street? One obvious answer was a sidewalk artist. There is a long tradition of self-portraiture in art, and this is my variation of it.

I could hardly place the subject of this drawing in front of me while drawing it. Instead I photographed myself in this pose and worked from the photo, ensuring that the distance from head to foot corresponded to my own measurements. The box of chalks shared by the two artists became my trademark and is shown beside nearly all my sidewalk drawings.

At that time I used kneepads because they seemed helpful, But actually they are not. When working extensively on floors the important point is not to put your weight on your knees in the first place. I learned that lesson after I got "housemaid's knee," a condition that causes the knee to feeling achy and cold at night after any small strain has been put on it. The trick is to put the weight on the body and relieve the hands and knees of it. For this I use my own adapted stool, named the "stomach hammock" by a fellow artist, because the stomach hangs in it.

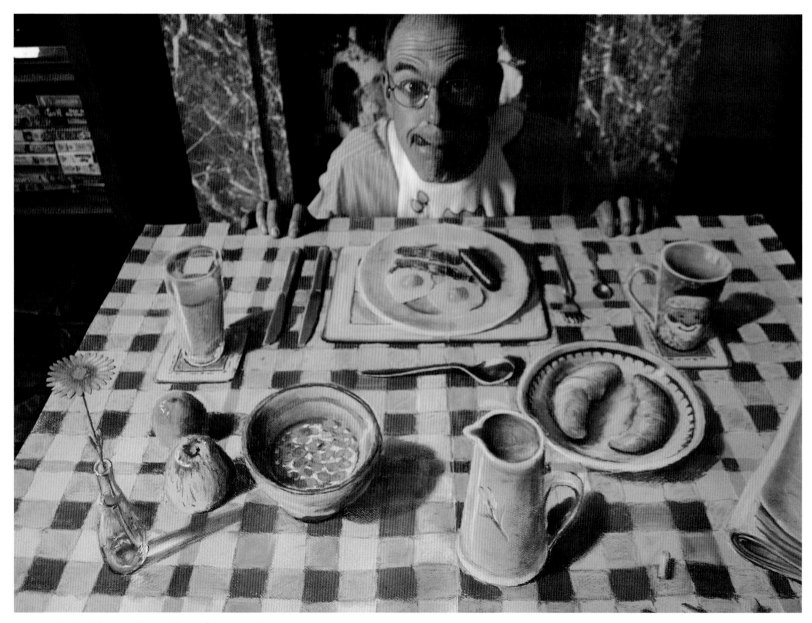

ANAMORPHIC BREAKFAST | NEW YORK CITY, NEW YORK

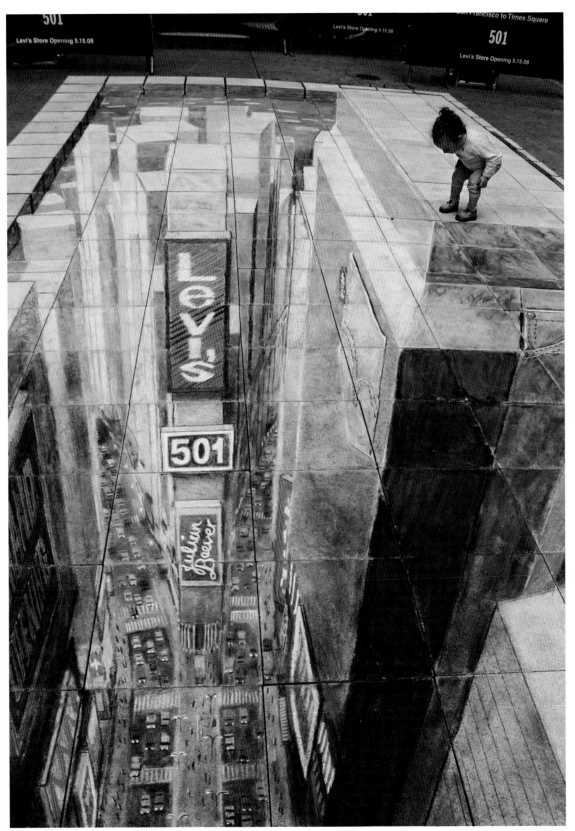

ANAMORPHIC BREAKFAST

When I visited New York City to do the project in Times Square, I was asked if I could do something for the "Today Show" on American TV.

There was no time to do a large piece, so at the last minute I began preparing this picture on paper at home on a tabletop. I took it with me rolled in a tube and completed it in the studio where I was preparing the *Times Square* drawing in Hoboken. The idea was that this picture could be in front of me in the studio while I was being interviewed. The Christmas coffee mug with Santa on it on was based on a real mug that I drank from at home. I took it along too and surreptitiously placed it on top of the drawing when the TV camera was looking elsewhere. This enabled me to surprise the audience by picking it up and drinking from what had looked like part of the picture.

It was the first time I have done an anamorphic on paper or on this close-up small scale. It offers possibilities for the future.

TIMES SQUARE IN TIMES SQUARE

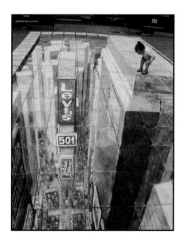

This drawing, commissioned for the opening of the Levi's® store, was executed on paving stones laid on top of the existing sidewalk surface on Times Square. While not an unusual compromise for me, this time it was different because most of the picture was actually done in a studio in Hoboken away from Times Square, and the paving slabs with the picture largely completed were transported to the site. The reason was practical: the very high fees for the use of space in Times Square meant that the picture's public display was limited to the two-day grand opening of the store.

Drawing on a surface laid down on top of an existing one has a number of advantages. It allows me to choose tiles of an ideal texture and to make drawings for sites where the actual surface is unsuitable. And the tiles can be brought indoors away form the vagaries of the weather. That said, in general, I much prefer to work outside on a real sidewalk in a real street if the right surface is available.

PAVEMENT CHALK ARTIST

MEETING MR. NEWT

This picture was drawn in Cologne for a German TV show. I first drew the outline of the hole in the ground using a rope to determine the shape. The water line below was similarly marked in. I then sketched in the lilies and the beast below with a view to placing my daughter in the composition. Finally I marked in the areas of color using chalk and powdered pigment.

Because my drawings are so much about childhood wonder they are ideally suited for children to be a part of. Also, putting a small person in the scene makes the image itself seem bigger. Working with variables such weather and the disappearance of daylight can be frustrating in itself. But placing my daughter on the water lily, trying to ensure that her heel was on the spot to make the surface ripples and asking her to hold the fishing rod and look at the camera, was especially challenging. Of course she was very young, and with a crowd looking at her and cameras pointing at her, the expectations were almost too great. It took many takes and sweet briberies to get it right!

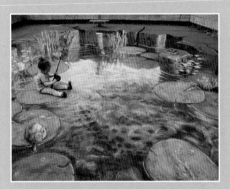

MEETING MR. FROG

I have always loved frogs. Like many children I reared tadpoles in a tank and watched them metamorphose. It was one of my favorite subjects to draw as a boy.

I sketched this out in a meeting to see if I could still draw frogs as well as I used to. It was drawn as a sidewalk piece in an arts festival in Salamanca, Spain, where their mascot was a blue frog. I had to argue the case to keep the colors naturalistic.

You never know how well an idea will come out in the end. Amazingly, when I put my daughter on the lily pad, she smiled and held the chalks up exactly as if the frog was truly sitting right in front of her — which of course it was not; it was flat on the sidewalk.

This picture is a special family souvenir to me, and whenever I am asked for my own favorite, this is the one — and not just because I like drawing frogs.

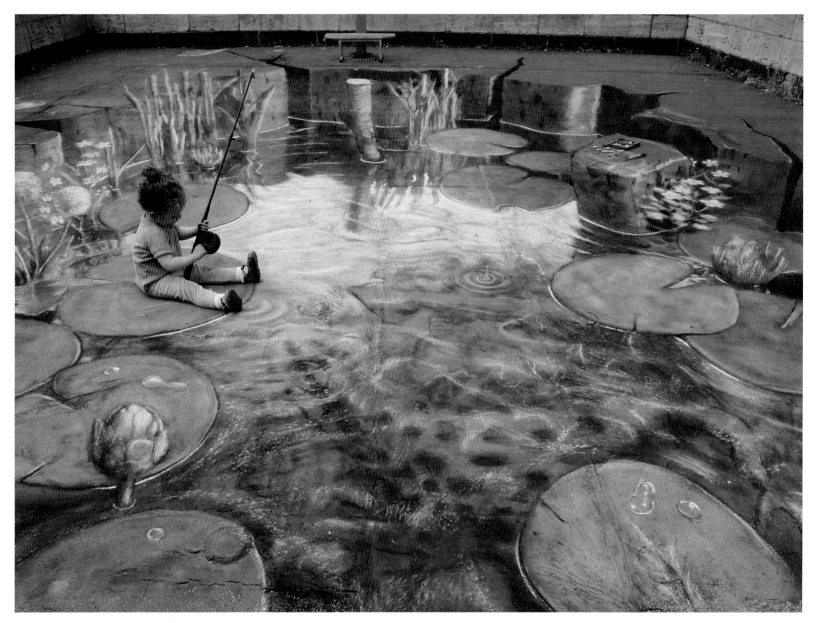

MEETING MR. NEWT | COLOGNE, GERMANY

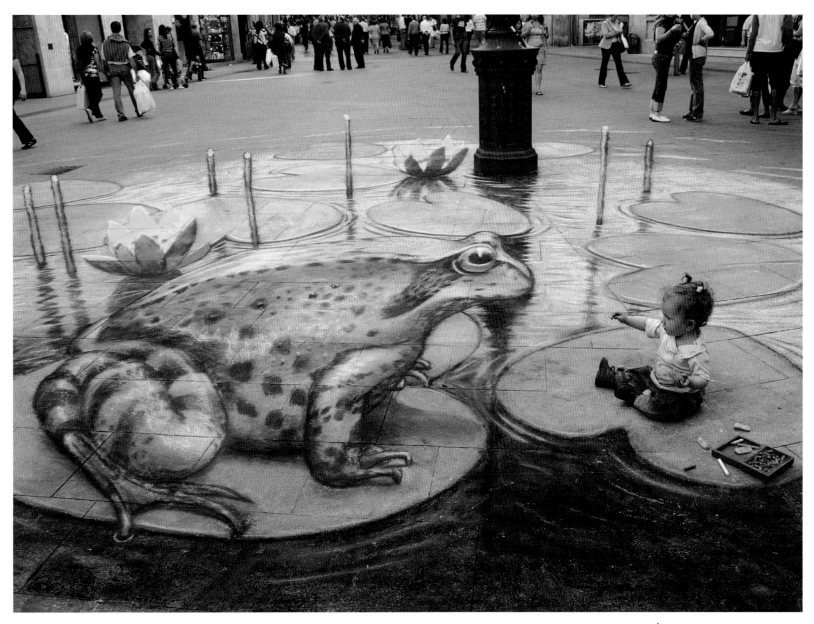

MEETING MR. FROG | SALAMANCA, SPAIN

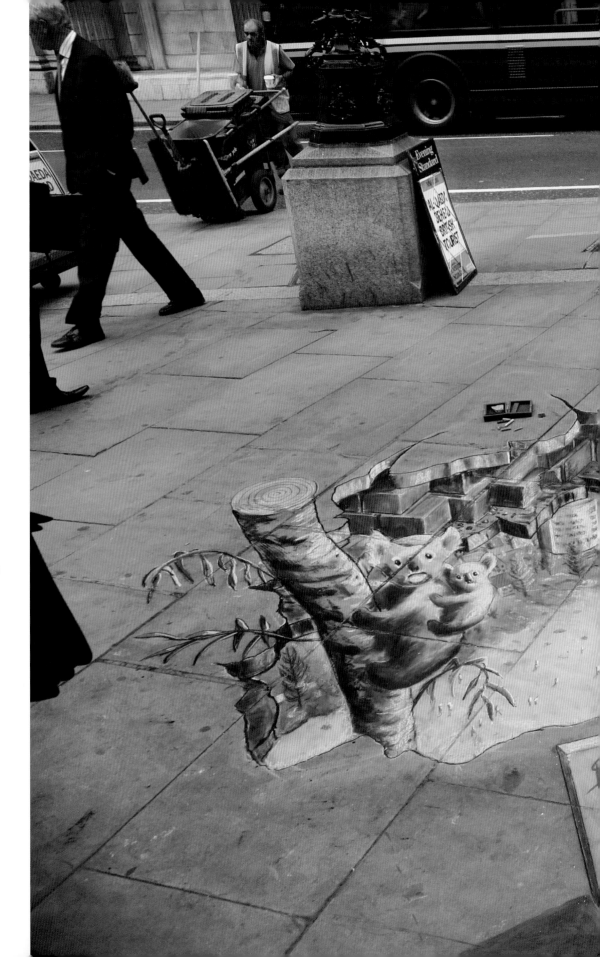

ESCAPE TO AUSTRALIA

LONDON, ENGLAND

The object of this drawing, commissioned by the South Australian government, was to entice London bankers and financiers to relocate to Adelaide. The hole in the ground is in the shape of Australia and the signpost in the shape of South Australia. The aerial view below is that of Glenelg Beach.

From experience, I am wary of this kind of aerial view seen in an underworld. The problem is that we are too far away from the underworld for it to be seen in 3D. Everything in the distance looks flat. Normally one can achieve a feeling of 3D when different objects or elements in the drawing are perceived as nearer or farther relative to the viewer and each other. Therefore a close thing looks 3D because a distant thing is behind it. But this principle breaks down when the whole view is distant. The only part that looks 3D is the edge of the hole, precisely because this is near to us in relation to the view below.

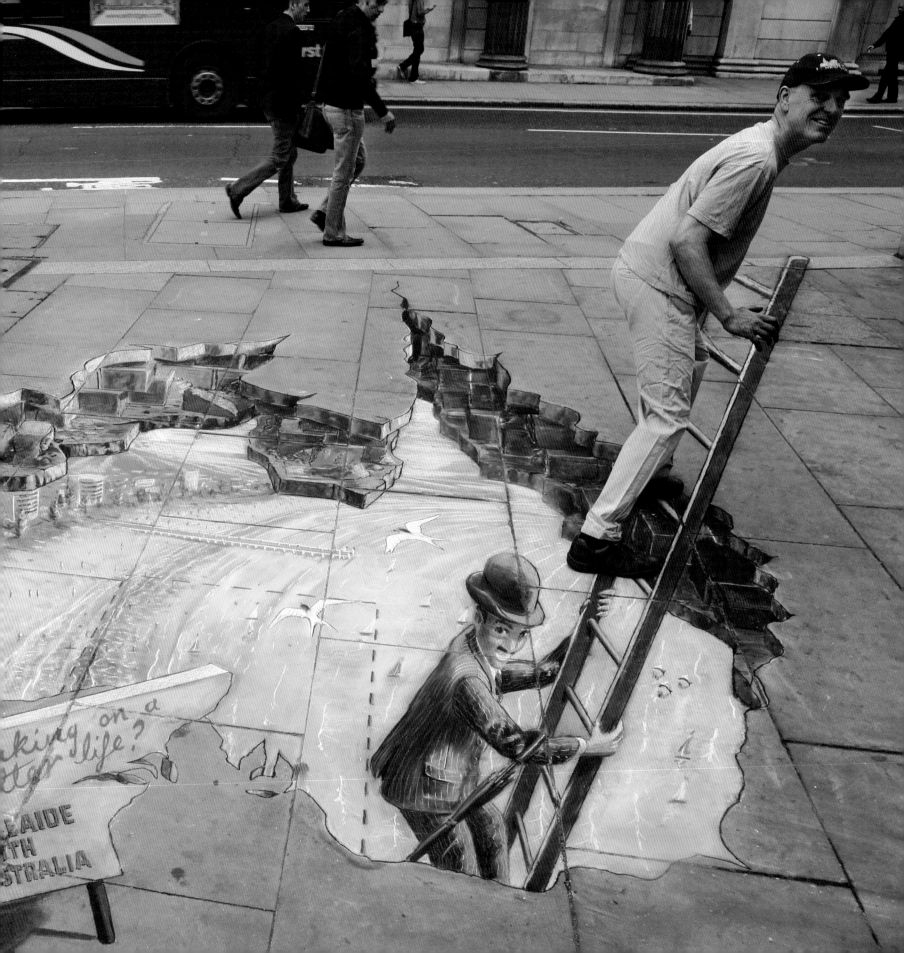

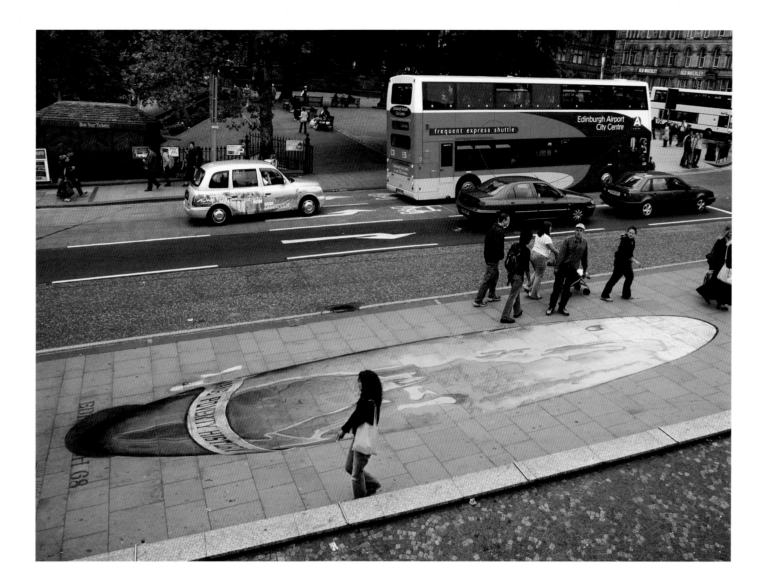

I am often asked my mathematical formula or computer program for making an object appear the right shape when it is drawn on a receding plane. "How did you manage to make that globe look round?" people ask. All I do is set up my camera on a tripod and look through it.

For this drawing, I held a golf ball between finger and thumb in front of the lens and went back and forth to the drawing arranging a rope on the floor until it corresponded to the edges of the ball.

I was asked to do this drawing by the organizers of the Live 8 campaign headed by Bob Geldof and other pop stars. Its aim was to make the delegates of the 2006 Edinburgh G8 summit cut a better deal for developing countries. I traveled to Edinburgh for this event and spent three days drawing it, including periods when the entire street was cordoned off and emptied by the police for security reasons. On the day of its completion, Geldof unfortunately decided to make his appearance not at the drawing, as expected, but at a press conference at the nearby railway station.

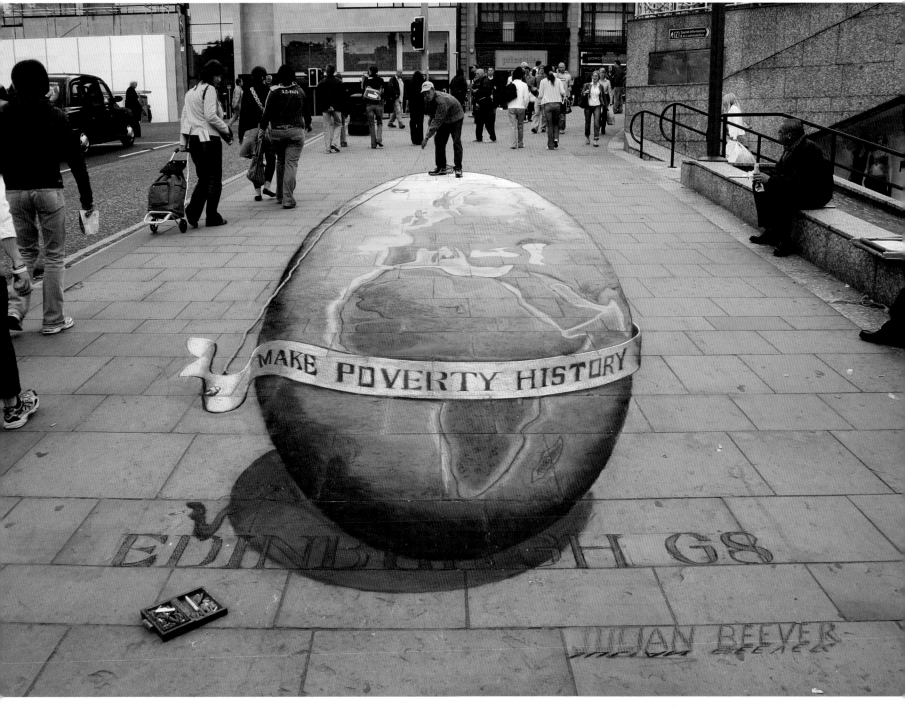

MAKE POVERTY HISTORY, THE GLOBE | EDINBURGH, SCOTLAND

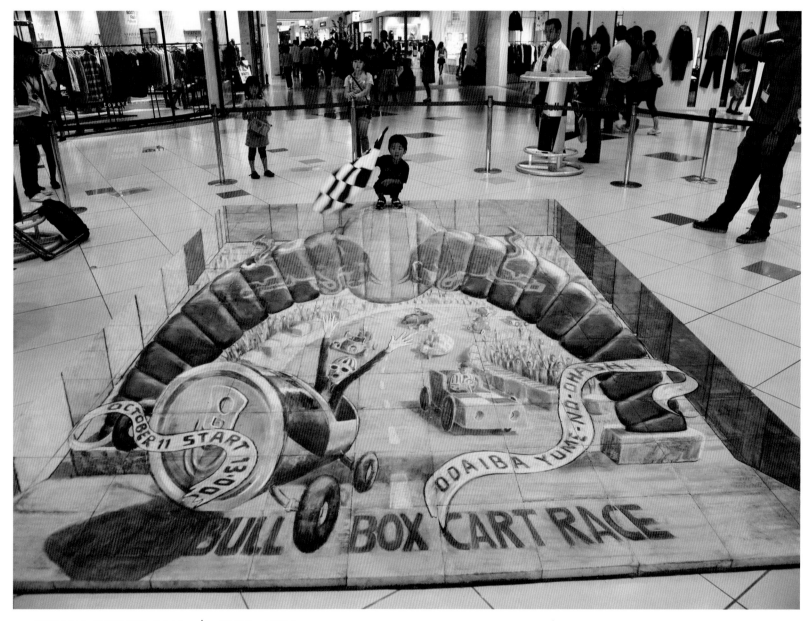

REDBULL BOXCART RACE | TOKYO, JAPAN

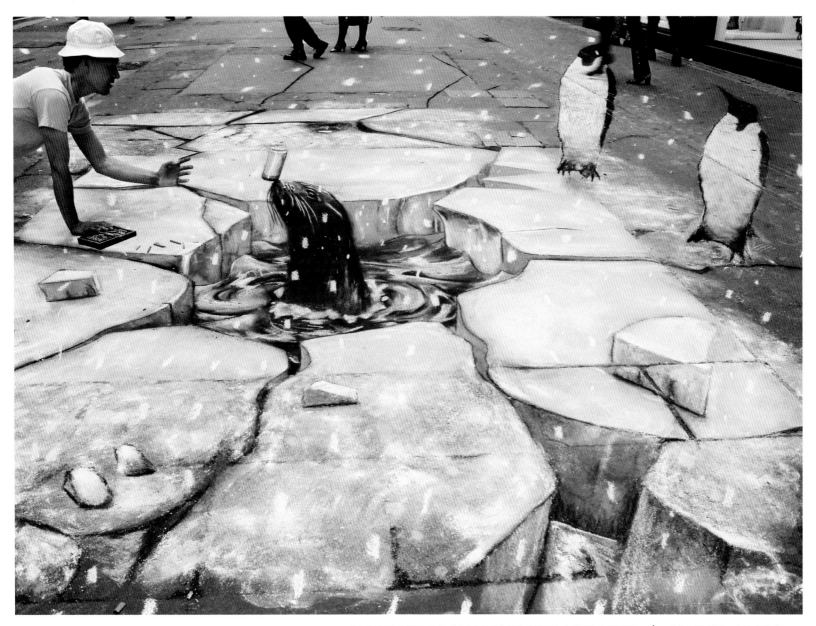

ARCTIC STREET CONDITIONS WITH SOFT DRINK | BRUSSELS, BELGIUM

REDBULL BOXCART RACE

This picture, done in a shopping mall in Tokyo, was very much a commercial drawing planned as part of an event to promote another event — the boxcart race. I was given specific instructions: it needed to illustrate the race and include all the taglines, the drinks can, the boxcarts and the Redbull arch. The passers-by should be able to pose on the drawing so as to be photographed on their mobile phones. With all these boxes that had to be ticked, it reminded me of a school project.

My first idea was to have the participant sit as if in a drawn boxcart. But the requirement to show it coming through the arch made this impossible. The arch, as the tallest part of the drawing, naturally had to rise to the far end of the surface area. Therefore the boxcart would have had to be drawn below this, nearer to the viewer, and the participant had to appear close as well. He would then appear very big, and the drawing and the arch would by comparison look pathetically small. My solution was to place the participant on top of the arch, that is at the back, waving the finishing flag. This meant the drawing and the arch by comparison appeared big.

I wanted to give the scene of the race a happy sunlit feeling, so I used bright warm colors with purple cool shadows. To make the scene appear to be going into the distance I reduced the contrast in the colors, as if we were seeing them through a lot of hot hazy air.

ARCTIC STREET CONDITIONS WITH SOFT DRINK

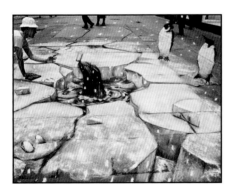

This was one of my early drawings, and the first picture in which I drew the floor composed as ice. I visited a local library and studied some photos of icebanks in the Arctic to see what kind of colors they were and how the ice fragments. The snowflakes came as an afterthought and needed to fill the pedestrian street all over. Naturally, to keep the flakes appearing a consistent size, I had to make them progressively bigger as they went away from the camera. Standing penguins, which on the ground had to be very long and stretched, were added at the sides. I did not get these to look as rounded and 3D as I would have liked, but this was early days and then, as now, I was still learning.

REMBRANDTS WITH REMBRANDTS

After drawing *Swimming Pool in the High Street* and finding I could make things look 3D on the sidewalk, I very soon thought my new technique could have commercial potential. Among the most suitable products, it seemed to me, were the pastel chalks with which the drawings were made. Actually, though, I now use very few Rembrandt pastels on sidewalks because they are softer than needed for most pavement work, and tend to break and wear down too quickly when used on a hard surface such as stone or cement. There are harder, more suitable pastels available.

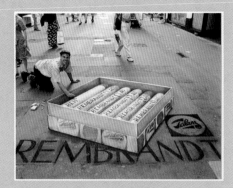

THE *SUN*

This drawing was done outside York Minster in England, to illustrate a feature item on my work that the *Sun* newspapers were carrying. The idea was that this would be a drawing of me drawing a stack of *Sun* newspapers, with the same drawing on the front page (which at the time was a possibility). I thought it would be a challenge to draw myself on the picture instead of actually posing this time. I used photographs of myself to help mark out the figure.

I come back time and again to the subject of surface and wind. The surface here was a bit too smooth and there was a persistent wind. For this reason the drawing is thin. On top of this, the joins of the slabs show through badly. In hindsight these should have been filled but time was an issue. The stack would also have looked more solid if it had been side-lit . . . a lesson I remembered for the future.

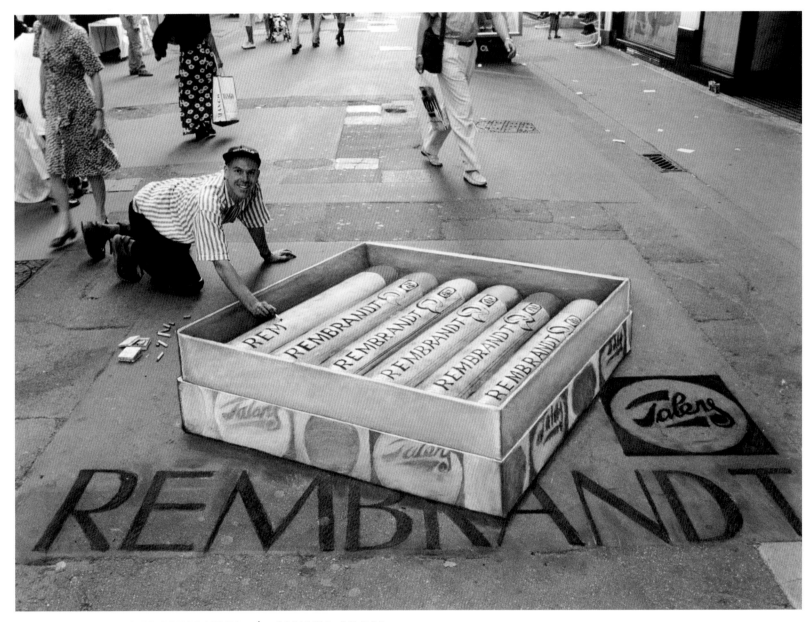

REMBRANDTS WITH REMBRANDTS | BRUSSELS, BELGIUM

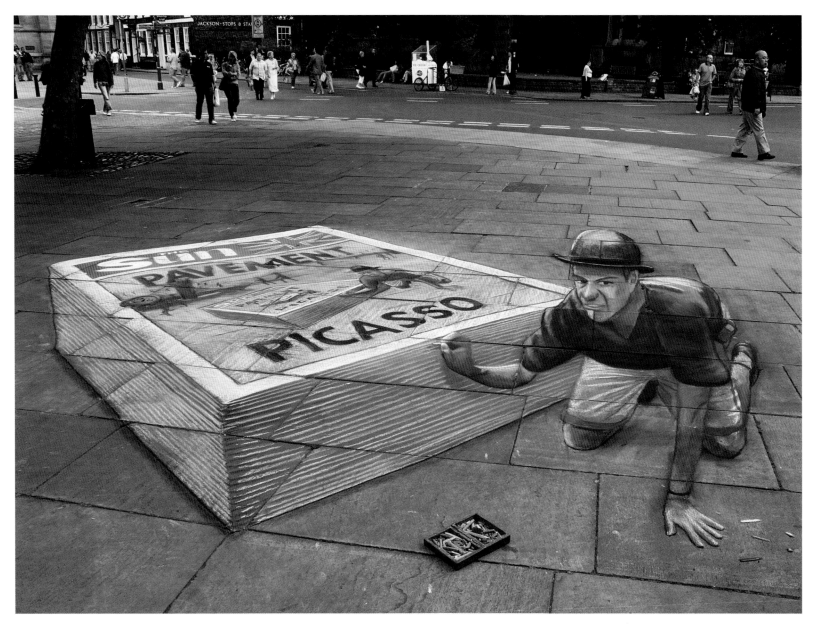

THE *SUN* | YORK MINSTER, ENGLAND

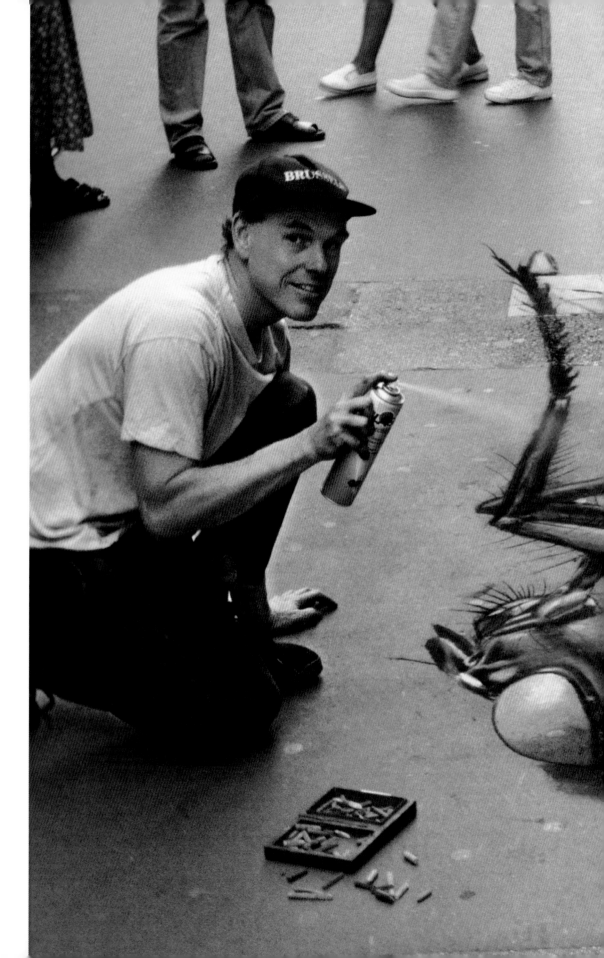

THE WORLD'S
LARGEST FLY SPRAY

BRUSSELS, BELGIUM

This drawing was among my early experiments, soon after the swimming pool, when I was trying out various ideas and sending photos of the results to suitable companies in order to solicit commissions. I hoped to appeal to a company that made fly spray.

I photographed the fly with a close-up lens and worked from the photo to get the result. Perhaps more than any other picture, this one confirms that drawing a small thing big works best. It also shows that a simple idea can convey a stronger message than a complex one.

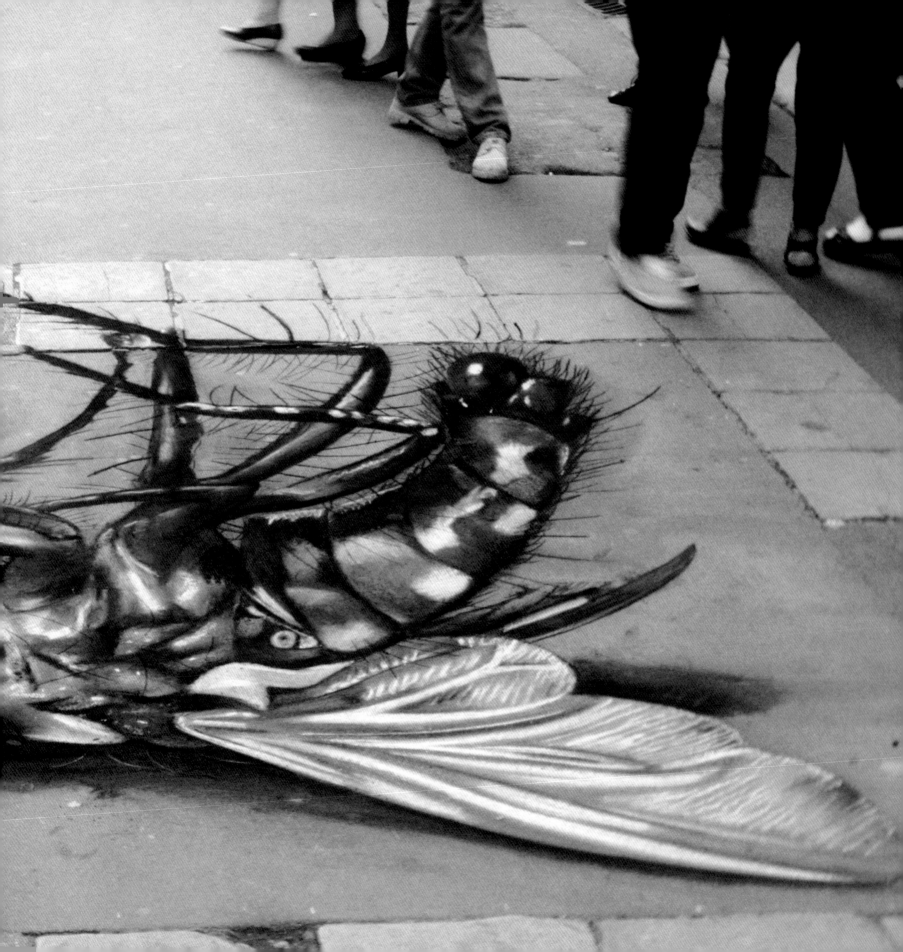

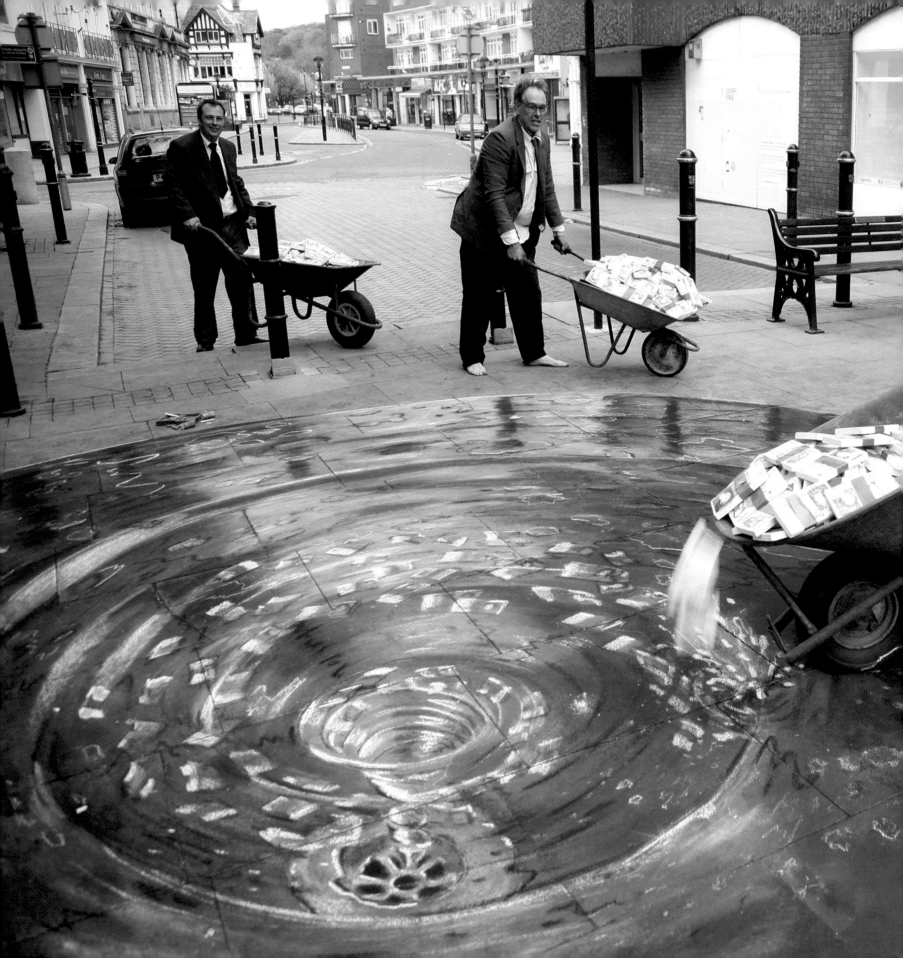

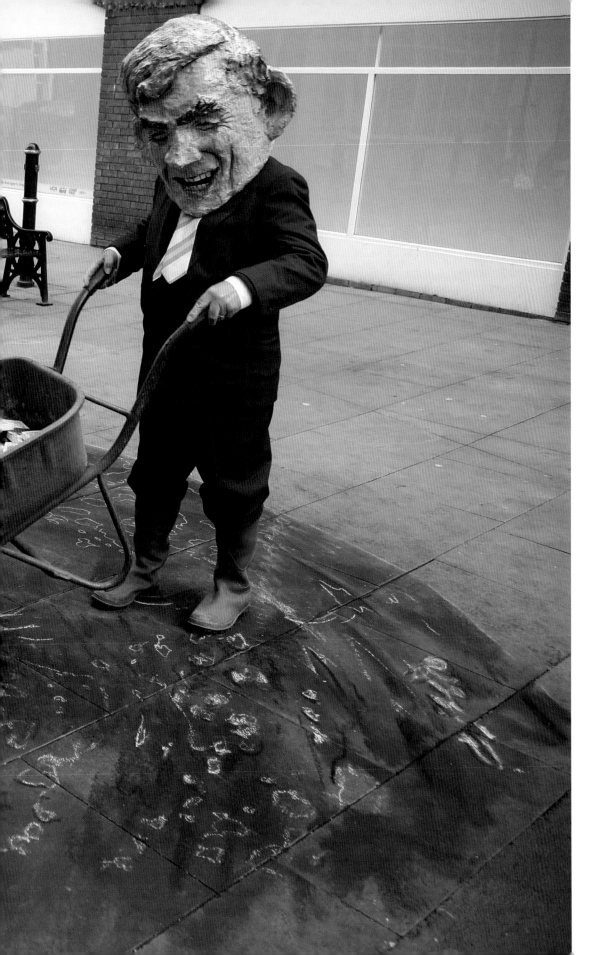

DOWN THE DRAIN

DOVER, ENGLAND

This drawing was done in Dover in England shortly before the 2010 general election. I tried to capture what I saw as the ethos of the previous five years.

The most time-consuming part was making the caricature mask, papier mâché not being my speciality. I found it hard to achieve the resemblance I wanted. It was also hard to acquire a sufficient number of banknotes to fill the wheelbarrows!

But the real endurance test was the blustery weather. First I had to soak up the water already on the surface, and with every shower I had to put down a plastic sheet and anchor it. Lots of recoloring was needed because the wind kept blowing the chalk off and scuffing the drawing.

I had studied the vortex created in a bath drain beforehand and taken photos. The reflections on the wider whirlpool in this location were harder to judge. Most, I assumed, would be dark — that is, they would reflect the surrounding buildings and enable the viewer to see below the surface of the water, where the stones themselves would be visible, though distorted. When stones are wet, they become much darker. So I found myself trying to keep the paving stones dry so that I could color them as if they were wet!

If I seem rather bulky in the background, it is not because of any large dinners but because of my many layers of clothing.

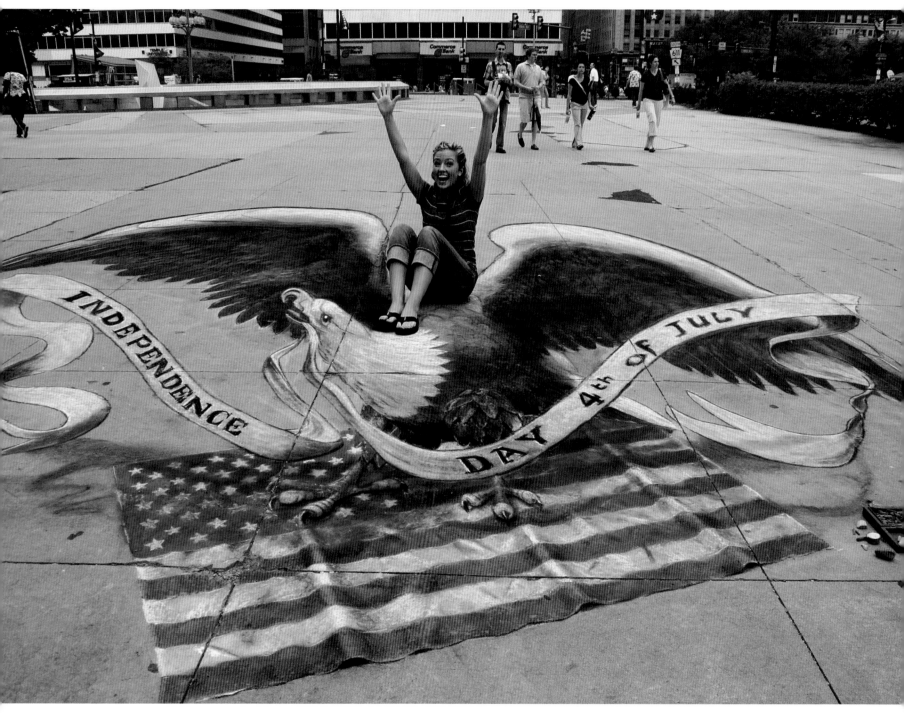

PHILADELPHIA EAGLE | PHILADELPHIA, PENNSYLVANIA

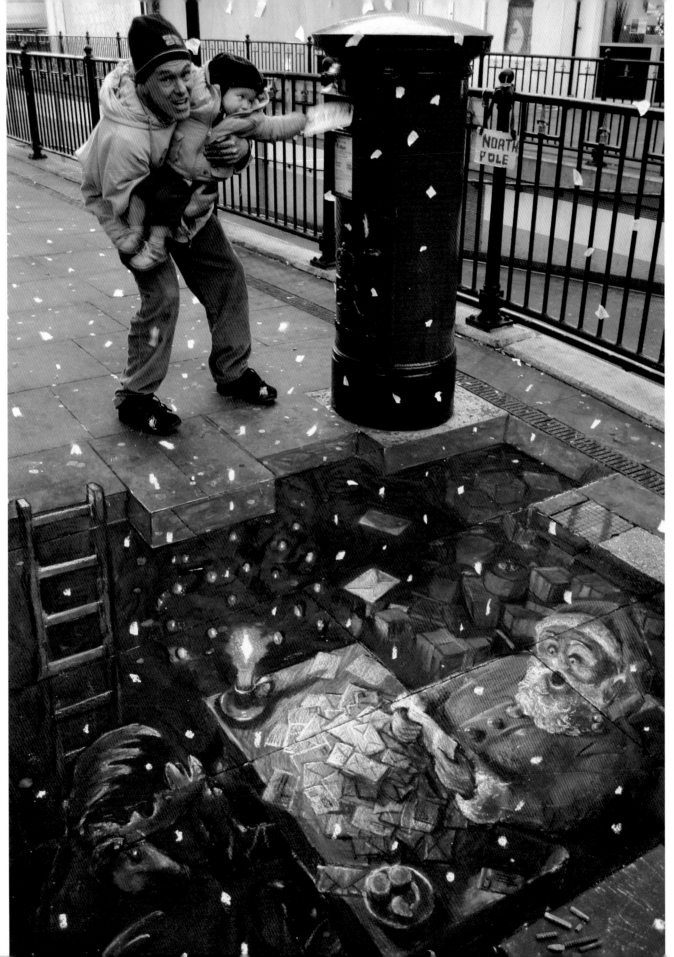

97

PHILADELPHIA EAGLE

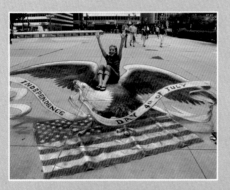

This drawing marked the first in the series for the TV show "Concrete Canvas." A subject was needed that had a connection to the city in which it was drawn — Philadelphia — outside the town hall, in fact. The obvious choice was the Liberty Bell but I felt that this was a lifeless subject that would not have made an exciting drawing. One suggestion was to draw fireworks because the drawing was to be done over the Independence Day weekend. But I could not find a way to draw these in a view upon which we had to look down, and be seen in darkness.

Instead I found this image, which started out as a black and white Victorian print. I brought color to the picture and repositioned the eagle over the Stars and Stripes.

The drawing was done over three days, which was a tight deadline, so I did not have quite enough time to fill out all the plumage in the feathers as I had intended. Soon after the filming, heavy rain destroyed it.

But in the meantime, it was a good drawing for people to pose on and many people did so.

PLACING THE ORDERS

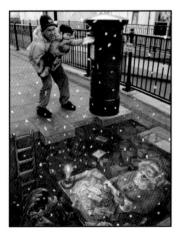

This was one of the few drawings that was done and dusted in one day. Usually the larger ones take nearer four. It was drawn not far from my home in Dover town center in England.

It was December 21, and I wanted to get it published in a national newspaper before Christmas. Since it was quite small, my plan was to draw the outline on the first day, leave it overnight covered by a plastic sheet and return early the next morning to color it all in. But the outlining went very quickly and easily, and since rain was forecast, I reconsidered my plan.

There was a busy nightclub nearby, so I knew there was no guarantee that the covers would stay in place overnight. I made the decision to push ahead for a same-day finish. At the end of the day the last part of the job was to paste pieces of white paper on to the background scenery to create the effect of snow over a wider zone than just the drawing. The reason this is not complete and that some of the flakes are the wrong size, is that time had run out. The photo was snapped in the last minutes of the fading winter twilight.

THAT HEMMED-IN FEELING

Shopping malls invariably have very hard-wearing shiny surfaces that will not hold chalk. Here, as a solution, I used slabs laid on the existing surface. I am often asked if I can work on canvas. I have tried it but was not happy with the result. Canvas and pastel don't seem to be made for each other; canvas is better suited to paint. So why not create paintings and save your work, people ask? First, paint is very slow. The reason I can achieve so much in a fairly short time is that chalks are a fast medium. Paints need mixing and time to dry, and cannot so easily be combined on the surface. Also, even matte paint seems to dry with a certain shine to it. If the canvas is facing directly up to the light, it is difficult not to get a horrible reflective glare that spoils any illusion that the art is part of its surroundings.

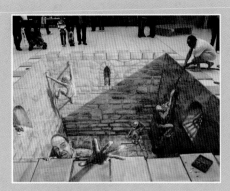

The figure hanging on a rope at the right was especially difficult to get right. The self-portrait at the front was easier but I did take some photos of myself hanging onto the side of a caravan for reference.

One detail most people miss is the flower clutched in the hands of the long-dead prisoner below. To me it was a reference to the chrysanthemum in *Escape from Alcatraz*, which symbolized freedom, or at least the freedom of mind that can never be crushed!

CATCHING A SALMON IN STOCKHOLM

This was a drawing I had sketched out on paper long beforehand, and it appeared to promise great things. It seemed a suitable subject to do for "Concrete Canvas" when I visited Stockholm, the seafaring city on the Swedish coast.

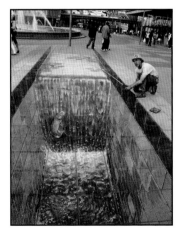

As usual all my vertical lines were plotted down to a vanishing point below the camera. The two bold black parallel lines were already there in the sidewalk so I tried to use these to my advantage, first incorporating them as the two opposite horizontal edges of my canal. However, because they were so dark, they didn't work as horizontal faces, which had to be lighter than the vertical faces.

I reconstructed the image with the dark bands as the upper course of vertical bricks of my canal wall. Light vertical joins had to be plotted down to the vanishing point to make this clear. In all, with all the bricks to draw correctly and then this major correction, it became an exercise in overcoming tedium. And when I finally got to the waterfall, I found it very hard to get right too. I did enjoy doing the salmon and think this partially rescues the piece.

You can't strike gold every time.

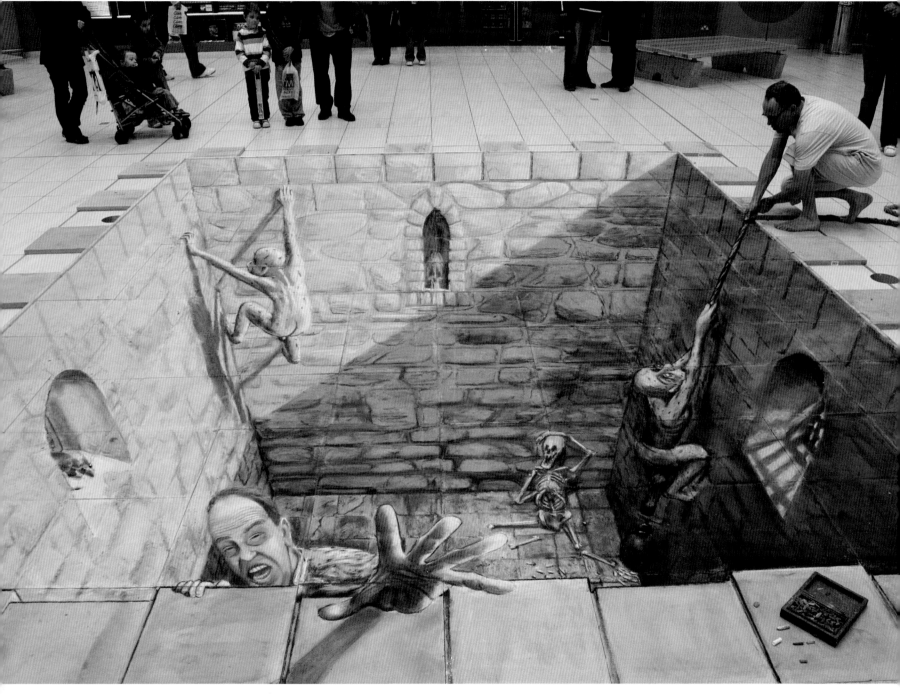

THAT HEMMED-IN FEELING | BELFAST, NORTHERN IRELAND

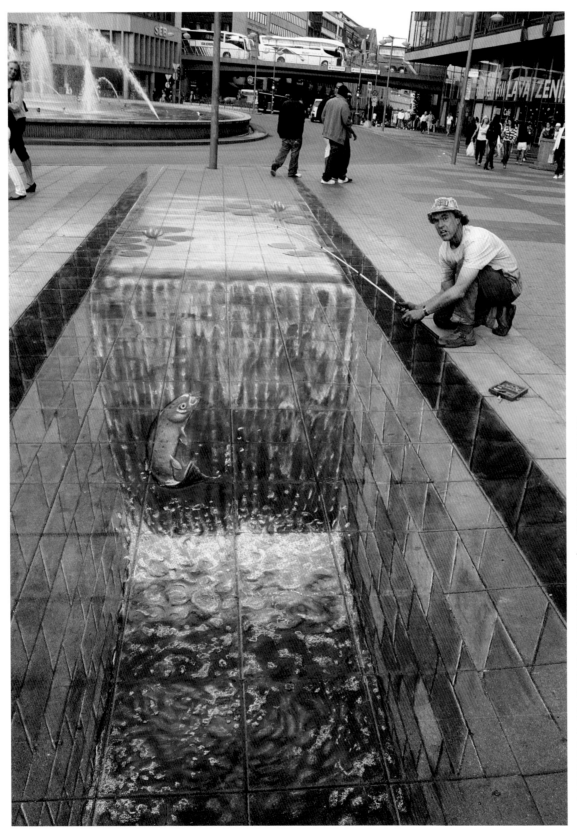

CATCHING A SALMON IN STOCKHOLM | STOCKHOLM, SWEDEN

101

YOU JUST CAN'T GET
THE REINDEER ANYMORE

BRUSSELS, BELGIUM

Although my drawings are essentially
done in chalk, for large areas I also
use the sort of powdered pigment that
traditional artists use in mixing their
own paints. I put the powder into flour
sprinklers, the kind cooks use to sprinkle
flour over their pastry. I then rub it into
the sidewalk with blocks of polystyrene
foam. I can mix up the precise color I need
this way. For the snow-covered ground I
wanted a cold pale blue. Had I used pure
white, the snowflakes in front of the pic-
ture would not have shown up.

 The higher in the picture, the larger the
snowflakes had to be; they were drawn as
oblongs pointing away from the camera.
Among the pile of spilled letters can be
seen the pink envelope marked "Santa"
posted by my daughter in the *Placing the
Orders* drawing.

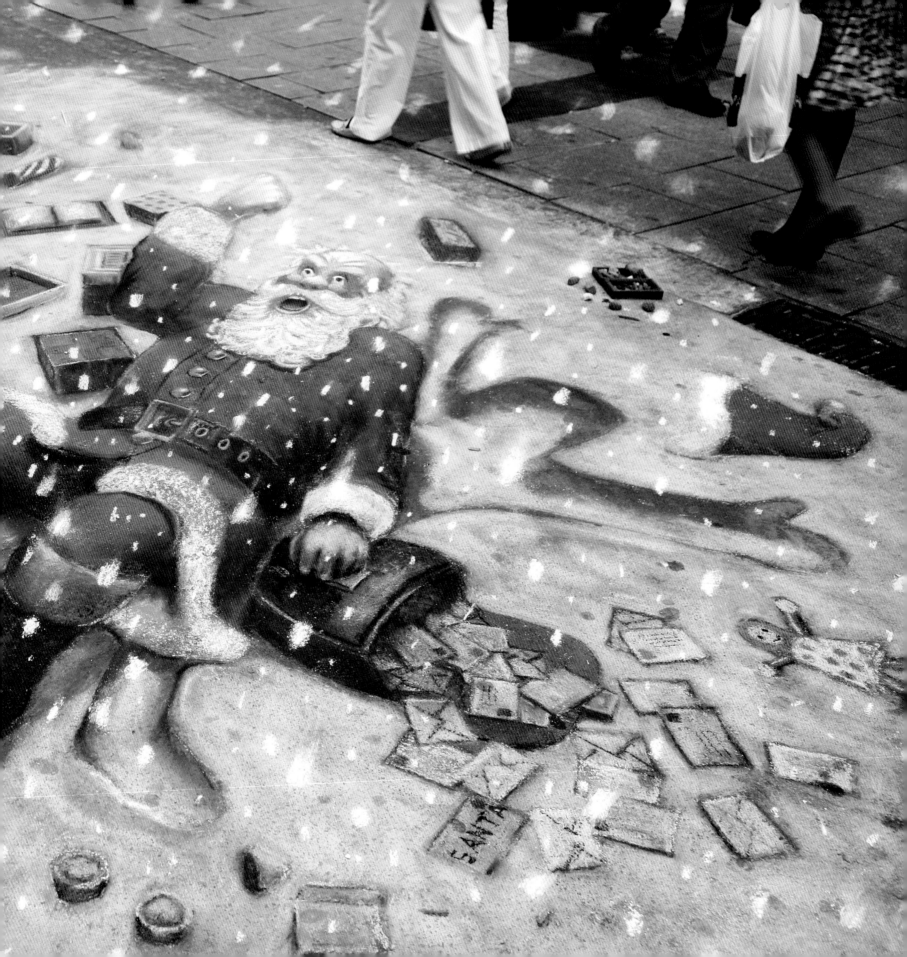

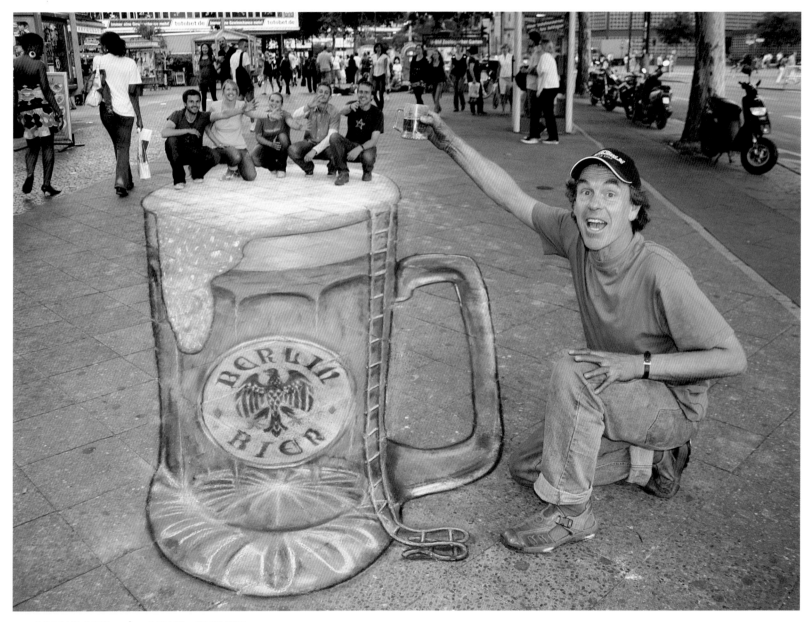

BERLIN BIER | BERLIN, GERMANY

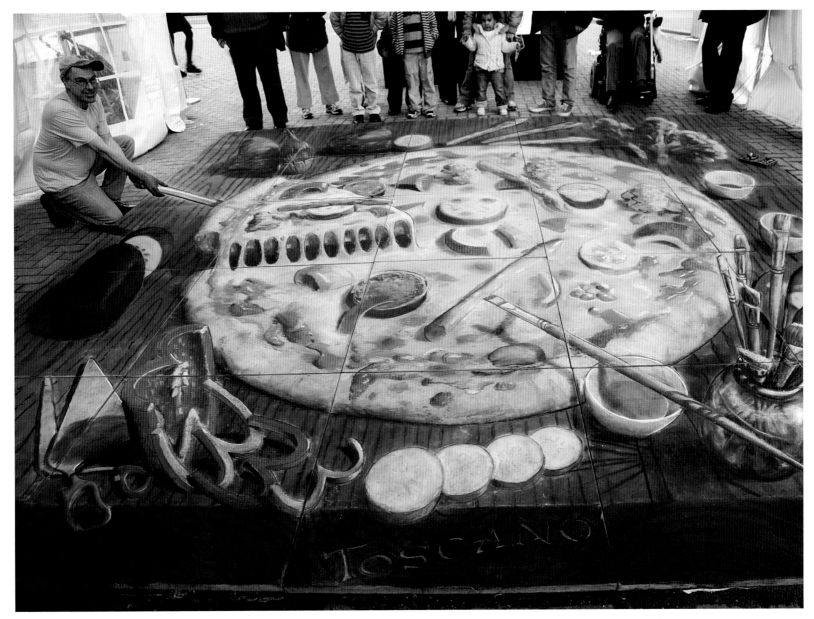

ANYONE FOR PIZZA? | TORONTO, ONTARIO

BERLIN BIER

This drawing, done in Berlin for the TV show "Concrete Canvas," celebrates one of Germany's specialities – its beer. I had proposed drawing Hitler with his hands up in a wrecked underground bunker beneath the sidewalk, but the producers sighed at my poor taste and told me to think again!

I think this design was a good choice because it enabled me to demonstrate the big man/little man effect that I discovered in my *Make Poverty History* picture. As usual, I mapped out the outline of the mug using a rope and checked the shape through the camera as I went along. I took a glass beer mug with me to use as a model, but I had to invent the logo on the side, using the German eagle from the old Deutschmark coin.

To give this some solidity, I needed to fill in the joins between the paving slabs, but I ran out of plaster and it was a Sunday. All the shops were closed. In the end a local hospital gave us some bandage covered in the plaster they used for setting splints; when mixed with sand it did the job.

ANYONE FOR PIZZA?

It is always more effective, at least in sidewalk drawing, to take a small object, such as a bottle, a frog, a butterfly or a pizza, and draw it bigger than life-size than to take a large object such as a building or a mountain and draw it smaller. Scaling up works, but scaling down doesn't. The mind likes to see things magnified, but to see things in miniature seems less interesting.

The idea of this drawing was to show the pizza, not only as a delicious meal but also as a work of art. Arranged around it we see some of the ingredients, and we also see the artist/chef's tools of the trade, brushes, oils and palette.

The arm stretching out to the pizza slice that I appear to be holding is indeed part of the drawing. The guy pushing the camera button had to work at it to align the hands and arm. Up a bit, a fraction to left, down a bit, back a bit . . . hold it at that.

BARROWFORD MILL

The building featured in this drawing is the one in which it was drawn: an old mill, converted into art studios in Barrowford, Lancashire, England. I enjoy using props such as this pole, which allow the real upper world to fuse seamlessly with the lower, drawn world. The camera need only be moved an inch to one side for the pole to become bent at the join.

Buildings are difficult subjects. They are by nature lifeless and geometric. Their multiple straight lines demand exact measurement and prolonged concentration, and when they are drawn, at best they provide a backdrop or setting for something more lively.

Even worse, when seen from far above they look like Toytown. Buildings drawn this way are so detailed that one can never really make them appear as real as in a photograph. It is much more satisfying to draw a small object large than a large object small.

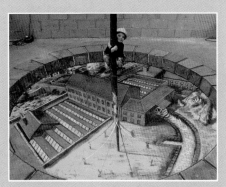

THE UNSTOPPABLE PROGRESS OF THE GARDEN MOLE

This drawing was an experiment. I am always looking around for new effects and subjects, and I was inspired by a wildlife documentary in which a small animal was filmed at ground level. It approached the camera, sniffling and snuffling, and came so close that its face obscured most of the view and went out of focus.

For this photo I brought the camera down far lower than usual, to about 12 inches (30 cm) above the ground, so that our furry friend needed only to be drawn small in the space near the lens. I then attempted to draw the mole's muzzle, which had to be further back, out of focus.

I drew the molehills behind the muzzle to give an effect that one was in front of the other. The molehills covered a far greater area than the mole.

I was not convinced by my out-of-focus effect, which looks simply unfinished in the photo. However, the use of the low camera opened up a lot of possibilities.

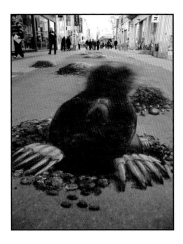

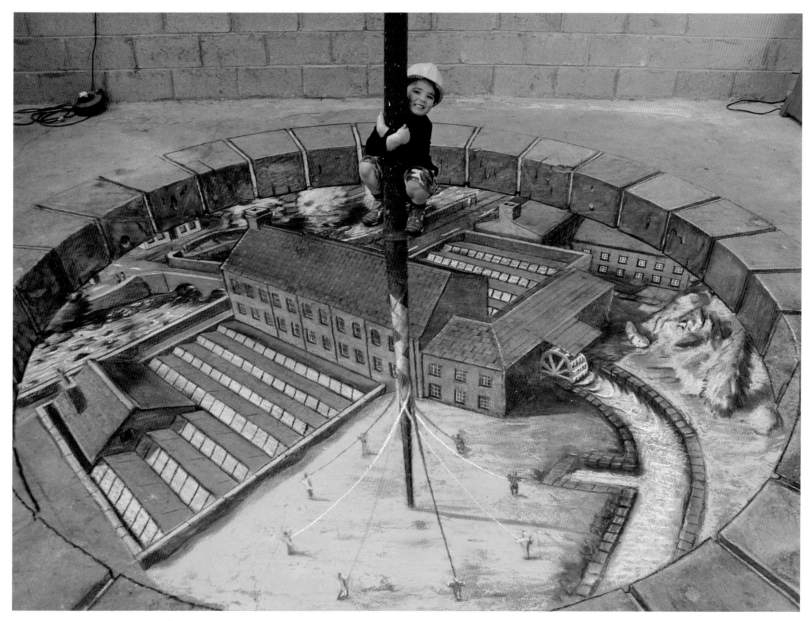

BARROWFORD MILL | BARROWFORD, LANCASHIRE, ENGLAND

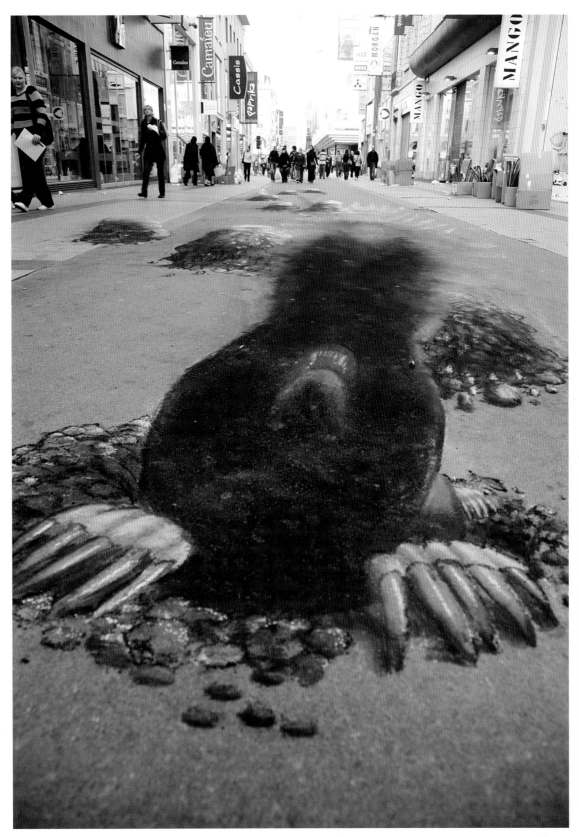

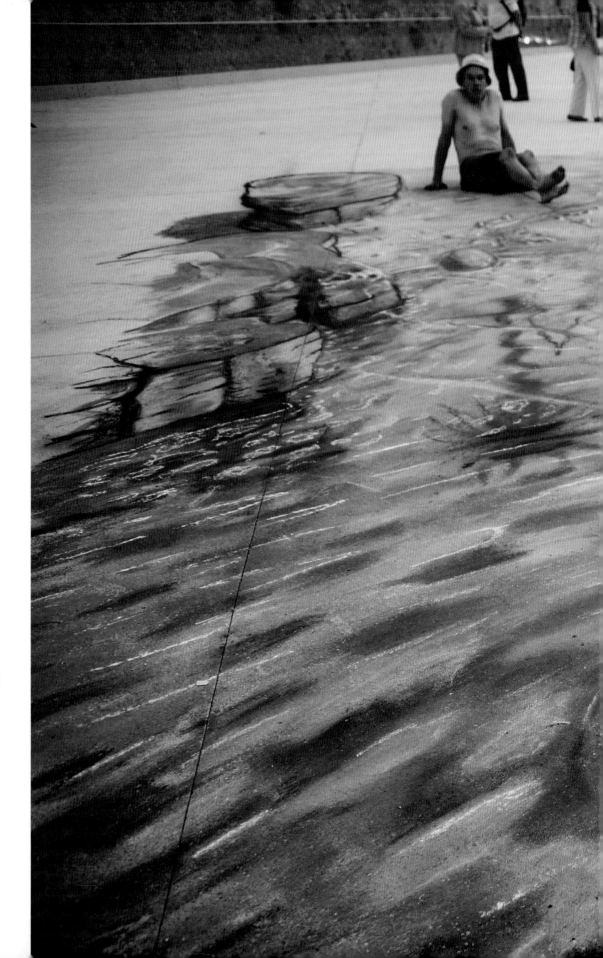

FISH SUPPER AT THE BEACH

CASCAIS, PORTUGAL

Of course, it is the bird having its supper rather than the man. This picture was drawn in Cascais on the Portuguese coast. It allowed me to play with one of my favorite subjects — water surfaces. There is not much measurement or calculation involved, and I rely almost entirely on instinct, observation of water and photographic records. There is a great freedom in it. The drawback is that if it doesn't work, no calculation can help me out.

The surface was rough and in this very open space at the coast, there was a lot of wind. Progress was slow, and I had to keep redrawing sections where the chalk had blown off. The rocks at the side took most of the time. Even though they don't appear very tall, at this distance from the camera they nevertheless had to be drawn quite stretched.

I often use a bucket of water and a sponge to make corrections. At one point during the drawing, one of my sun umbrellas blew over in the wind and upset the bucket which poured its water across the beach in a dirty stream. Rather than make a bigger mess clearing it up, I decided to let it dry and incorporate the stream as if it really was a stream running down the beach.

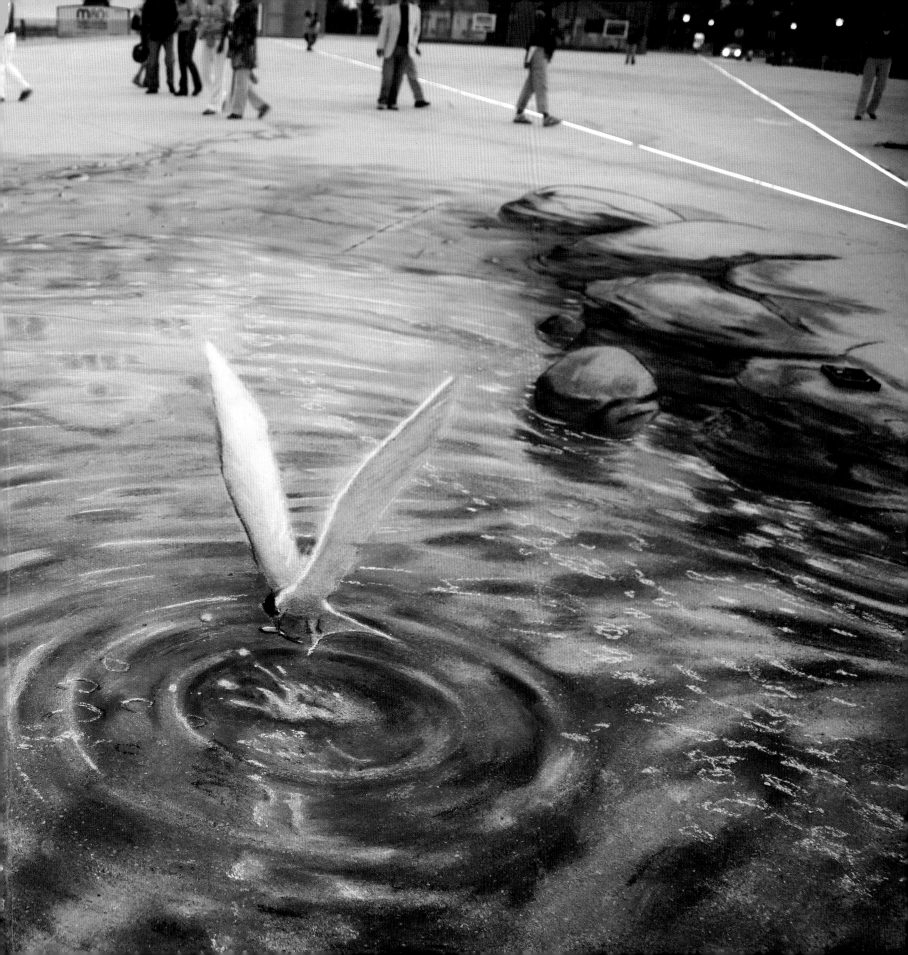

CREDITS